FIGHTING *for* MY LIFE

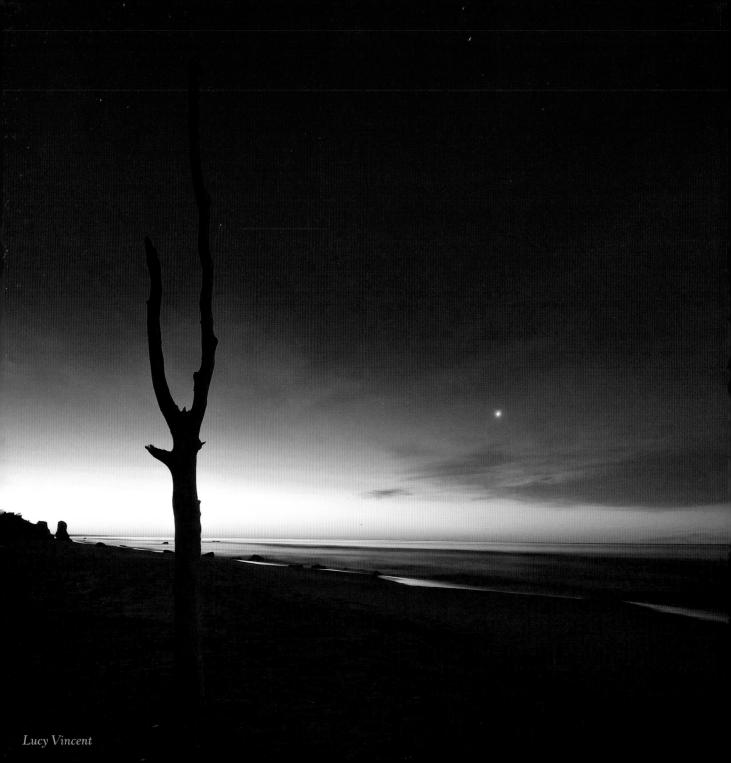

Lucy Vincent

FIGHTING *for* MY LIFE

FINDING HOPE AND SERENITY
ON MARTHA'S VINEYARD

MICHAEL BLANCHARD

Vineyard Stories
Edgartown, Massachussetts

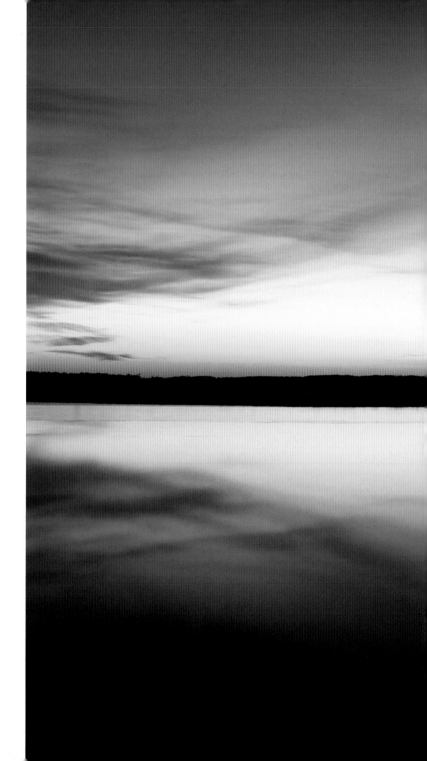

Published by Vineyard Stories
52 Bold Meadow Road
Edgartown, MA 02539
508 221 2338
www.vineyardstories.com

Library of Congress: 2014942093
ISBN: 978-0-9915028-4-4

Book Design: Jill Dible, Atlanta, GA

Printed in China

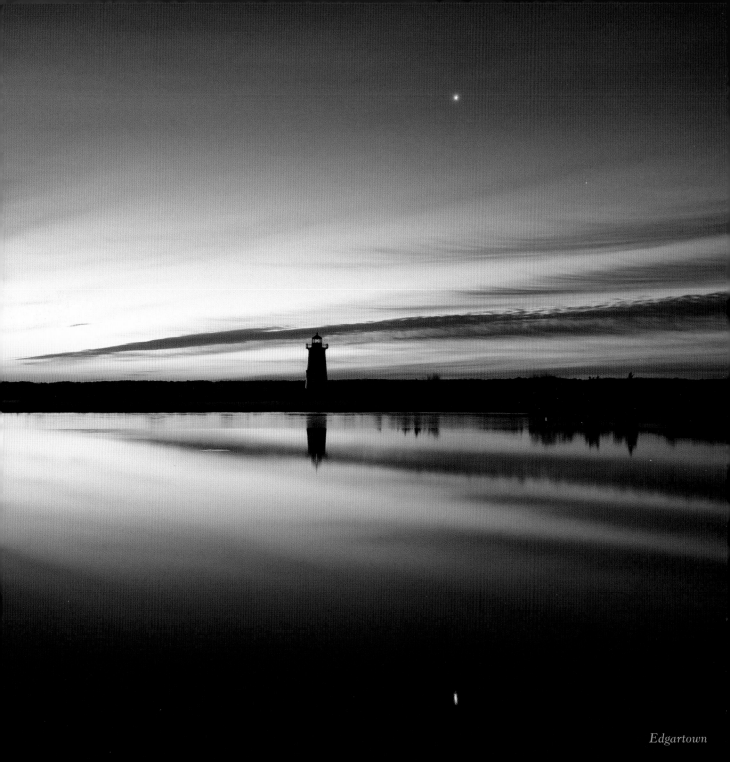

Edgartown

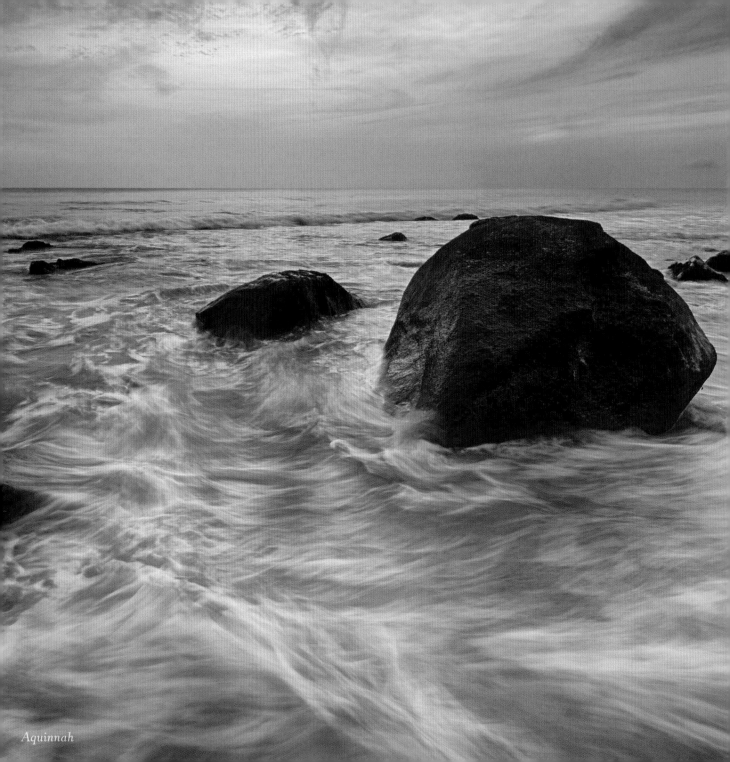

~ The End ~

THE BEGINNING OF MY STORY of discovery and passion for photography begins at the bottom. Rock bottom.

It was 2 a.m. I awoke in a strange and cold place with bright overhead fluorescent lights, numbness and tingling in my wrists, and the gentle and yet stern look of a Massachusetts State Trooper. I still remember his smile and how odd it seemed to receive empathy from a police officer who must have known this was my third DUI in three months.

I was unsure how I got here. I knew this was Massachusetts, but where? I realized this was a hospital emergency room, but the last thing I recalled was the awful fight with my wife on the phone and my determination to drive from Maine to Boston to see her and make it right. I remembered nothing else. Above all else, though, I knew one thing: this was the third time in three months I had been caught driving drunk. This would change everything.

I was the chief operating officer of a large company headquartered in Maine. I clearly had the ability to make good decisions and decisively lead people. I was much too smart to get arrested three times in three months. These events were the result of an unfair act of nature and the seemingly incalculable odds of having three police officers strategically placed in my path. The odds of getting three DUI's in rapid succession are mind-boggling. Incredibly bad luck. Not my fault.

I had already hired the best attorney money could buy to take care of my first two arrests. He was making significant progress to help mitigate those. The first had been in Maine where I vomited all over both front seats of my Jeep just prior to being run down for speeding. As I sat in this brownish vomitus of considerable stench, I actually argued with the police officer over his ridiculously strict interpretation of the speed limit in pulling me over for going 63 in a 55 miles per hour speed zone. The conversation was incredibly short, and the town was happy to exchange my soiled clothing for an orange jumpsuit. The second DUI was in Massachusetts for another marginal speeding violation of 74 in a 65 miles per hour speed zone.

Just bad luck, inconceivable to me.

I was rescued both times by my wife after a night in jail.

But this third arrest was different. I couldn't remember anything, and I still can't. I had purchased Xanax on the Internet to "wean" myself off vodka, my preferred drink. I never thought I would drink the vodka and take Xanax at the same time, leading me to black out on my way to make things right with my wife. The trooper in my hospital room described my attempt to drive away as he knocked on the window of my car while I was asleep by the side of the road with the car running. I was apparently startled and promptly accelerated, running over street signs and eventually coming to a stop, where I was wrestled to the ground and handcuffed.

This was the first time I experienced a complete and total blackout. As I lay on the hospital bed, shock slowly passed, depression set in, and the reality of my situation and likely

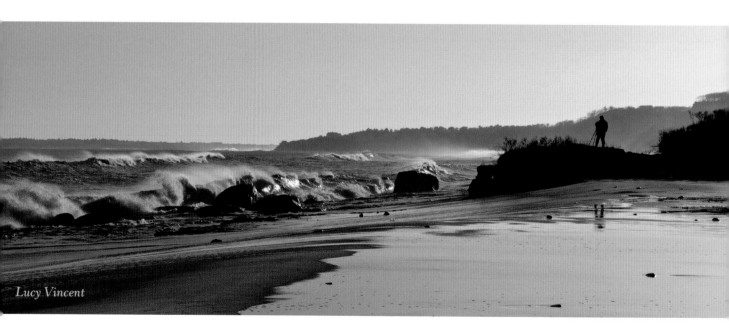

Lucy Vincent

consequences, created a numbness and sickening anxiety. The life I previously knew was over. Choice had been eliminated. The option to continue my life in this self-chosen hell, the life I had been leading for thirty years now, had been deterred. Suddenly I felt a deep and consuming desire to end it all. I had reached that point alcoholics call "the bottom." That cold and lonely realization that life itself is impossible to contemplate in the absence of alcohol but knowing the drug has destroyed the very essence of your soul.

Jails, institutions, or death seemed to be the only available options. I choose the third. I was ready to check out. I was done.

As I lay in the hospital bed, I began to see myself as those I loved did: I was a lying and deceitful drunk who threw everything away while devastating those close to me. I was consumed by alcohol. I was infected with an incurable disease that would eventually kill me and maybe kill others. The only answer seemed to be to take the remaining thirty Xanax pills with my quart of vodka and get it over with.

It would be a noble act, meant to redeem me and demonstrate I cared for others and stood for something.

It was twisted, cowardly, and selfish.

BECOMING AN ALCOHOLIC

ALCOHOLISM ISN'T A SINGLE DISEASE. There are variations, and mine took years to develop. Some individuals drink from the first experience of euphoria and continue until they repeatedly black out. Others develop over the years and have the ability to function and serve as contributing members of society.

I started drinking as a means of relieving stress in my twenties (I am now fifty-six at the time of the writing of this book). The need for alcohol ebbed and flowed with each of life's crises and the frequent realizations that my life had no purpose. It did not matter what possessions I had or my status in life. I continually found the gap between expectation and reality unacceptable. My lack of direction was combined with low self-esteem and a co-

dependent need for constant reaffirmation. I constantly looked for ways to calm myself, to provide sedation to a soul in turmoil.

I didn't see the alcoholism coming. I missed the signs:

1) Teenage disappointment. I had only one goal—be a professional baseball player. Injury ended that goal, and I literally had nothing else.

2) Insatiable need to be better—never good enough.

3) No self-worth.

4) Took comfort in isolation—a loner with dogs who enjoyed the woods more than people.

5) Constant motion.

6) Preferred chaos.

7) Fear of finality.

8) Consuming sense of guilt when putting my needs ahead of anyone else's.

9) Self-image dependent entirely on the good opinion of others.

10) Insatiable need to relieve stress through long distance running.

Without any clear direction or compelling reason for existing, I embarked on the only path of experience—I followed in my own father's footsteps, trying to climb the ladder of success and ignoring everything else.

I did succeed, and at a rapid pace. At the age of twenty-seven I managed an entire hospital laboratory with close to two hundred employees—many of them twice my age. Every two years I switched jobs, always with more responsibility and more money. I never looked back and severed relationships as easily as they were made. I seemed to connect closely with folks but always left them behind despite their exceptional efforts to stay in touch. I was selected for every job I applied for—never defeated—always number one. I was a manager, a director, a consultant, a salesman, a national speaker, the head of national associations, a vice president, and a chief operating officer—a recognized leader in my field.

Life was good. I attacked relentlessly and took no prisoners and made no friends. Although I often wondered if anyone would show up at my funeral when I died, I'd shrug off the thought as insignificant. I'd be dead, after all.

If pressed, however, I would admit there was some collateral damage during the ascension to the top. As my drinking gradually escalated, I devastated two beautiful women, now my ex-wives, who put their trust and faith in me. I hurt other women who loved and cared for me. I fathered two children—two angels, a boy and a girl—and then let them down. I missed important family events. Once, while very intoxicated, I vomited blood on Thanksgiving Day while passed out on the floor. My son was there for me that entire day and night for fear of leaving me alone.

My daughter was devastated through divorce. I broke my personal vow of integrity and self-imposed expectation of leading the perfect family unit. I worried friends and family by keeping contact to a minimum and withdrawing from conversations related to my personal situation. But on the flip side, I was an amazingly successful businessman who was good at sales and demonstrated empathy for employees as long as they didn't get too close. I was the model employee and constantly sought by recruiting firms and other companies.

I was one sick, successful drunk.

THE CHASE

MY PHYSICAL PASSION WAS RUNNING, and I had completed over ten marathons. Running less than seven or eight miles was a waste of time. I needed that true feeling of euphoria and release from life that kicked in after the ten-mile mark. The wind hitting my face, the smell of trees and nature, even the biting winter air gave me a relief that transcended everyday life. And I was good at it: in the ten marathons I ran, I achieved the three-hour mark in several of them and completed one event in 2 hours and 55 minutes. Running was my only connection to something greater than myself. I cherished the daily one or two hours of freedom and held that time as sacred.

Little did I realize running was sedation with natural chemicals called endorphins. I knew I needed the sedation; I seemed to be in a constant state of chaos and flux, always chasing serenity. The endorphins worked well for many years, and after returning from a long run I could sit and take a deep breath. The deeply satisfying gut level inhalation of air served as the acknowledgment I had momentarily reached a sense of peace, serenity, and connection. That moment however, was fleeting, and I sadly wished my body could sustain multiple runs—so I often ran both morning and night. But as I got older, I couldn't withstand the pounding and damage to my deteriorating frame. As mileage dropped and euphoria became harder to achieve, the one or two glasses of wine each night turned into three or four and eventually to vodka. This process was an almost imperceptible shift in quantity and frequency of consumption.

Another strategy I employed to find peace, serenity, and purpose was to hike to isolated locations. My most frequent destination was Mount Washington in New Hampshire. This six-thousand-foot peak is not easy to climb, which restricts the number of visitors and offers the kind of environment I thought I needed to communicate with God. But after several failed attempts to hike to the summit and learn my purpose, my disease really took over, and I decided to try it intoxicated. Filling my water bottle with vodka I ascended the mountain with renewed vigor, convinced the alcohol would remove the "thinking brain" and put my subconscious in connection with something I thought of as my higher power.

Yet after reaching the summit and meditating really hard, I got up and started back down, truly disappointed. My efforts had failed just as in the past. And this gave me even more reason to calm myself with drink. Several days later I read a passage from a speaker who eloquently described searches for meaning in isolation. He stated individuals will only find what they bring with them—emptiness breeds emptiness and meaning is not granted or conferred but is earned by helping others.

My chase for peace had turned from a quest for meaning to the continual quest to sedate. I subconsciously realized I would never catch what I hoped to find and the only thing I had left was relief from failure. This was the place of ultimate hopelessness. Oddly, running was as

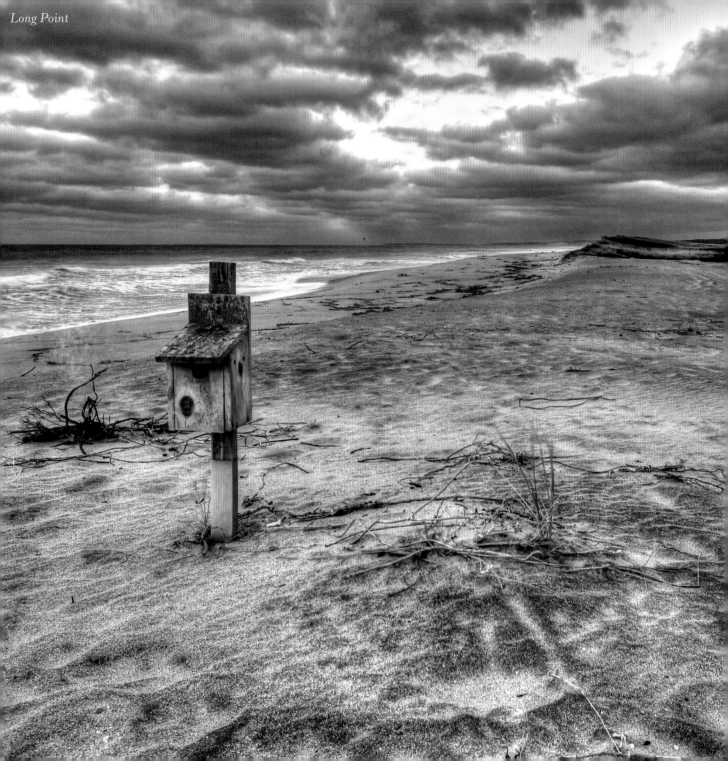

Long Point

close to stillness as I could come. The stillness of evening, between the last run of the day and bedtime, could only be tolerated through sedation by alcohol.

I remember so clearly the night, six months before the DUI's, staring at a quart bottle of vodka and debating my evening run. I would normally run first and then drink the vodka. But this time I guzzled the straight swill, and all hope was lost.

The last thread of "me" was now gone. My life became solely about managing the availability of alcohol and maintaining a "buzz" at all times to ensure my daily success. There was no other important priority in my life.

THE FINALE BEFORE THE END

I FILLED MY DAYS WITH WORK and my evenings with running and alcohol. Not a great existence, but tolerable. But alcoholism is never a finished product. The disease constantly evolves as the brain craves increasing levels of satisfaction. Just as an athlete's muscles are able to handle increasing stress with conditioning, the brain develops tolerance and can handle more (demands more) alcohol to be satisfied. The evolution was so gradual it didn't occur to me that drinking in the morning before going to work was a problem. Just another day at the office.

As I progressed through my early fifties and the DUI's were within earshot, my relationships changed, and my lies became more difficult to remember. I inflicted pain on many who were close to me. My father used to describe life as a coffin with ends kicked out so you could live and breathe six feet under. My life emulated his analogy. This process of slow deterioration could have lasted another twenty years eventually leading to illness, death, or some other dismal outcome. We all know the stories of the aging father or grandfather who couldn't or wouldn't seek help for alcoholism and eventually died of liver disease or a car accident or similar fate. I was destined to follow that story line. But then I took a chance and got a date with girl from an on-line dating service, while I was still in a serious relationship with my girlfriend who loved me very much. I was good at lying. To make it worse, my

girlfriend had just discovered the magnitude of my alcoholism and had arranged to send me to a detox in Florida—far away from family and friends who might discover my problem. But I got this date with this beautiful woman named Linda who was eight years younger than me. What an ego boost. I still had it! My girlfriend doesn't need to know—take another shot of vodka and carry on.

The Merriam Webster Dictionary defines soul mate as: *noun* : a close friend who completely understands you; a person who has the same beliefs and opinions as another person. I could see on the on-line dating services this was the definition most people aspired as they searched for their soul mate for long walks on beaches and sipping wine over dinner. Under that definition, you're supposed to marry and live happily ever after—at peace with the person who truly understands your needs to the core.

For me, finding a soul mate meant pure hell—and it came in the form of the beautiful woman named Linda.

My soul mate ripped my heart out, exposed my flaws, drove me crazy, almost killed me, and in the end, helped save my life.

My relationship with Linda was painful; the fights intense, and the subject matter always cut to the core. Her biggest fears were my greatest attributes; but they were her attributes as well, and vice versa. It was nerve racking to consistently see your face in the mirror but have that face talk back and tell you things you didn't want to hear.

We were both workout addicts; endorphin chasers; marathoners; introverts; loved nature; had skin blemishes in the same locations, sustained the exact same injuries, had thinning hair; demanding fathers; lacked self esteem; needed others to validate our value; didn't like going to the bathroom in a public restroom; and even liked squash soup. We both had an unexplained need to escape to Martha's Vineyard. We were clones—and we would discover later that she, too, was trying to find a way to stop drinking and be at peace.

This was way beyond compatibility. It was scary.

But as I prepared for my one week at the detox facility, arranged by my unsuspecting girlfriend, I called Linda on the phone to apologize for both lying to her about the "other

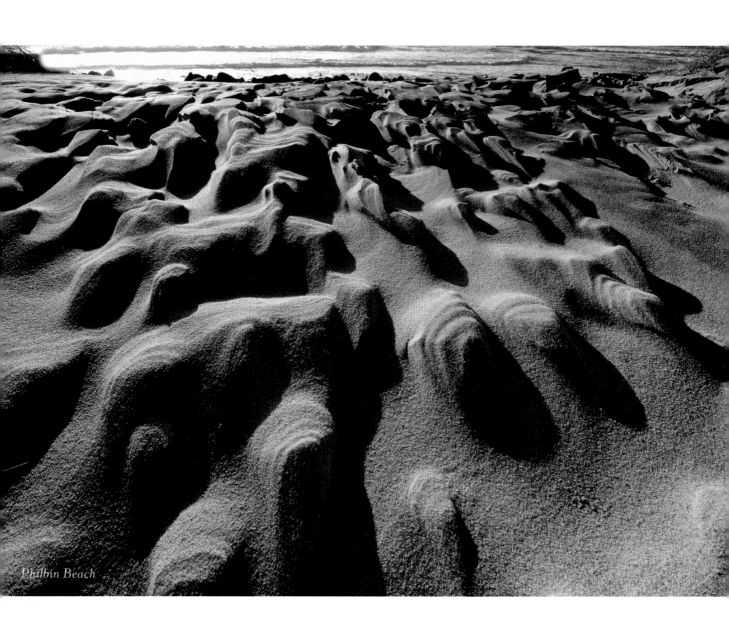

Philbin Beach

FIGHTING FOR MY LIFE

~ *16* ~

woman" and to tell her I wasn't the person she thought I was. I was a drunk and was heading to detox and wanted to say good-bye. She answered my call while standing in a field on Martha's Vineyard near her home, where she'd been praying that she would break the cycle of intense workouts capped off by wine.

On the phone, we set aside our rocky beginning and pledged a vow of sobriety. I returned from detox, and we jointly embarked on a mission that achieved an eighteen-month existence without alcohol and ending in a wedding ceremony on St. John—and we didn't drink while in the Caribbean!

I moved to Maine to take a position as the chief operating officer of a large company. That was the death knell. Imagine insecurity compounded with separation. Also imagine sobriety dependent on one other individual who constantly picked at your soul. Linda was my only safety net in staying sober while serving as the most likely instigator of my need to return to alcohol.

For an alcoholic, the term sobriety must have two parts: abstinence from the drug or alcohol and a change in who you are. Despite my stint in detox and the eighteen months with her, I was still the same person who started drinking in the first place, every flaw and insecurity still in tact with a belief system that egotistically focused on me as the center of the universe with little regard for others. It didn't take long for me to buy and consume that first nip of vodka.

Then off to the races.

I had eighteen months of abstinence to make up for. But this time it came with agony. Total hatred of self for breaking down and giving in. I argued and fought with myself, bought quart bottles of vodka at the pharmacy only to come home and dump the contents down the sink after two or three large gulps, vowing to never drink again. Then off to the store again—maybe just one more bottle. Then there were the fights with her. I had never felt such frustration and anger and thirst and need to consume alcohol.

She knew I was drinking, and she hated it. Each of my three DUI's came after slamming the phone down because of her threats to end our relationship. I wanted release from this torture but knew deep down I would never find this mysterious connection with another individual again.

So off I went to the pharmacy on an empty stomach. Grabbed the quart bottle of vodka and hit the road to get this straight once in for all—face to face—mano a mano. I never made it.

Each time, there were three strategically placed police officers…

RECOVERY—THE REASON FOR THIS BOOK

BACK IN THAT BRIGHT AND COLD emergency room in Massachusetts with my new state trooper friend, I declared my strategy to end it all. They then had the gall to send me to a psychiatric institution. This is where the process of hope and recovery began, and where this book began, why I am on a mission to help other addicts and alcoholics.

Buddha was right: "When the student is ready, the teacher will appear."

My teacher appeared in the form of a doctor who had traveled my path in an earlier stage of his life and was able to understand my place with empathy and wisdom. He was willing to stay by me and defend his decision to send me to a rehab facility he once visited himself. He worked with me from my psychiatric hospital bed and convinced me there was a glimmer of hope. He saved my job and kept me out of jail and helped save my life.

The teacher had appeared even when the student wanted to die, and at a time when jail or death—or rehab—were the only other choices. To have people willing to create the literal rock and hard place is a miracle for an alcoholic.

Having been to a previous rehab facility, I questioned why this place was any different. My MD savior touted the importance of intensive soul work combined with the tending to medical needs of depression and bipolar disorder I clearly exhibited. Medicine together with therapy over a three-month time span—long enough to start a new habit of meeting life on life's terms without intoxication. So I entered this rehab facility in Atlanta, Georgia, far from home, and incredibly scary because of what was going to be demanded of me. It was one of the most expensive centers in the country. I would be away from work and family for a seemingly endless span of three months—one quarter of a year. Wow. I was unsure if I would have a job or a family to return to. My thoughts were frantic and scrambled: *maybe no job; maybe no family; financial*

ruin; lost relationships. What would I say when I got back? They must have seen my three DUI's in paper; I am a joke; I am a loser; my life is over; my kids think I am worthless. And to top it off my sister came with me on the plane to Atlanta to make sure I actually showed up. During the flight I looked over and told her I wished the plane would crash. Clearly it was still all about me.

I could write a book on rehab, but that's not my purpose. For now it's sufficient to say the three-month sabbatical from life taught me who I was and the importance of friendship, community, and caring for others. Inner soul work combined with a "coming out" led to the realization that life achieves richness in community and not self-centered existence. For the first time in my life, I had friends. I had helped someone who had felt lower than me.

And then, I was ready to leave.

When the plane landed in Boston I felt an eerie sense of isolation. I was now vulnerable in a way I had never felt before. My wife had hung in there, and my family seemed open to giving me a chance. My employer had paid me short-term disability and authorized the insurance company to pay ninety percent of my rehab stay. This gesture of empathy seemed insignificant as I tried to contemplate facing all of those I left three months earlier. I repeatedly convinced myself that I should quit my job and become an addiction counselor. It was time to get off the ladder and live my life—not my father's.

As the taxi drove through Boston I stared at the multitude of billboard ads for various alcohol products. Each suggested a key aspect of human existence dependent on alcohol to live to the fullest. "Real Men salute with Russian vodka." Can't climb mountains and experience the real outdoors without a six-pack with the guys at the end of the day. A restaurant advertisement offering a romantic night out with different wine paired with each course. If my wife leaves me, how will I ever find another mate without alcohol?

I had no driver's license for at least a year. The thought of buses and riding bikes to work seemed overwhelming. Maine has almost no public transportation; what if one of my employees were to see me standing on a street corner in Maine waiting for a bus? It's bad enough employees may have seen my DUI's in the paper, but how do you act as a chief operating officer without a driver's licence?

As I approached home in Cambridge, my mind continued to race, and the noise in my head became unbearable. I grabbed my phone with my newly launched Alcoholics Anonymous application and asked if there was a meeting nearby. I exited the cab at our home in Cambridge, Massachusetts, at 11:30 a.m., saw there was a noon meeting down the street, threw my bags in the apartment, and ran to the meeting. I was late, and the meeting had started. They recited the serenity prayer and welcomed me with open arms. I was home.

REHAB EPILOGUE

THE YEAR FOLLOWING MY RUN DOWN Massachusetts Avenue in Cambridge to the noontime AA meeting was difficult. I sometimes think back and can't believe I made it. I have been told battles are won or lost in the trenches and each move has meaning with hand-to-hand combat.

My emotional energy was divided in three ways: healing with my family; surviving work; and staying sober through a relearning process. During the first year I was consumed with anxiety and fear over basic acts daily of living. Getting to work without a license; getting back and forth to Boston to see my wife and daughter on the bus; lining up cab companies and drivers to fill in the blanks; fighting legal battles and further attempts to put me in jail; getting rides to AA meetings; passing by alcohol in the pharmacy, gas station, grocery store, convenience store, highway discount liquor stores—and then the barrage of TV ads. Alcohol is EVERYWHERE!!!!

The rehab facility insisted on two weeks of "vacation" or readjustment time prior to returning to work, after coming back from the three-month hiatus. I started to count down the days to when I had to walk back through the doors of my office building. For two days I circled the building repeatedly telling myself there was no way I could do it. The embarrassment—all eyes on me as I passed through the door. But somehow I summoned the courage to enter and in the first two weeks met with each of my direct employees who knew the whole sordid tale. Each let me know they had lost all faith and confidence in me. Each had recommended I be fired and removed from the company when my boss solicited their opinions during my absence. Other employees couldn't believe I had the courage to come back to work again—some folks

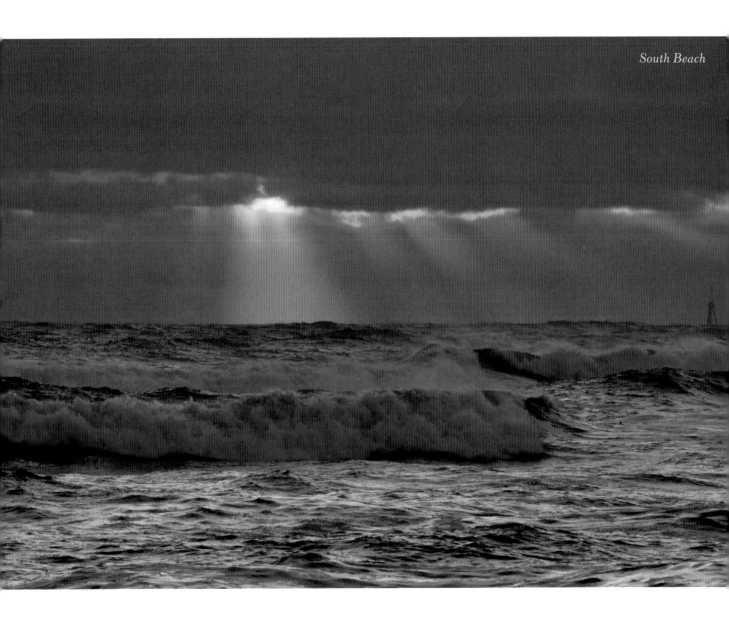

South Beach

were quite frankly amazed I actually showed up. The emotional drain at work was incredible, only to return home in the evening to a phone relationship with my wife that seemed constantly headed for termination. On top of these stresses my daughter began to suffer depression, which I concluded could only be blamed on me. And each day I went by the pharmacy and the gas station where I previously bought liquor. I found stray bottles of vodka long hidden away in closets and drawers. Each trigger to drink had to be re-rehearsed with a new script, similar to the need to relearn to walk after a brain injury. And I had to deal with all of this sober because I know that death, jails, or institutions, were the only other options.

But there was a major difference: I no longer hated myself. I had somehow found a way to love myself and that I was a caring and decent person. I had an inner strength that reduced life to minutes and hours rather than days and years. I became truly grateful for the friendships and blessings I had received. I wasn't alone anymore. And I discovered a magical place of refuge called Martha's Vineyard where my wife and I escaped to on weekends at her home of fifteen years. It kept us together and served as a spiritual center that surpassed the connection I used to get from running. I discovered an emotional tie to a geographic location I couldn't explain. My walks on the beaches and cliffs stirred emotions often leading to tears of joy—and I didn't need alcohol to connect to this mysterious energy. Amazing—truly a miracle.

I had graduated with my diploma from the school of hard knocks and vowed to do something with the education I received. I had burned through over $50,000 in rehab and legal fees, and I was determined to transform this absurd and embarrassing expense into money well spent. AA and recovery groups were life changing, but I wanted to be creative and make beautiful things, despite not having a creative bone in my body.

Finally, the catalyst, the answer, came in the form of a motivational speaker at my wife's graduation from her masters program. The speaker told an emotional story of an individual who suffered severe depression and found photography therapeutic. This individual took photos in nature and then spent hours using software to create beautiful works of art. He became absorbed in the process and channeled his pain and deep-seated emotions through the computer to the images he created.

I had zero knowledge of photography. But I had fearless independence, and I never wanted anyone telling me what to do, so I declined photography classes or instructors. I embarked on a self-education program of books and videos that I played and read relentlessly each evening on my I-pad while on the elliptical trainer at the health club. Dark clouds, bright colors, and turbulence—I could actually project my feelings into a photo and feel free. But most of all there was the connection with my higher power out on the Aquinnah cliffs, Lucy Vincent beaches, and Long Point fields. I felt such freedom, peace, and happiness. Sleep was less important, and I experienced genuine excitement with no alcohol in my system. And to top it off people seemed to like my work enough to buy it!

For me, I found my focus both through photography and in spending time on Martha's Vineyard. The connection with the Island was so strong I had no motivation to take photos anywhere else. And further, the therapeutic effect of editing photos and the channeling of emotions occurred only with Martha's Vineyard images. I photographed much of the Maine coast but had no interest in working with those images and creating "art." The connection with the Vineyard was deep and unexplainable.

I also found photography was the perfect opportunity to give back, to show these pictures as lessons that I have learned and things that have comforted me. I found I could offer these as gifts, both to myself and to others.

I found my Vineyard serenity.

It would be easy for me to do nothing more than become self-absorbed and make money. I am good at self-absorption, and it will take some of that skill set to be successful. But I will never forget how lucky I was with fancy rehabs and expensive lawyers.

I hope you have enjoyed my story and the many photographs that touch my soul and are presented in this book. I have now been sober for four years. Over the course of these years, I learned lessons the hard way. And I learned to mix this wisdom with images that resonate the core sentiments for me. Whether you are an addict or alcoholic or know someone who is—or are looking to find more meaning from life—I hope these words help and provide a sense of hope.

Because with hope, anything is possible.

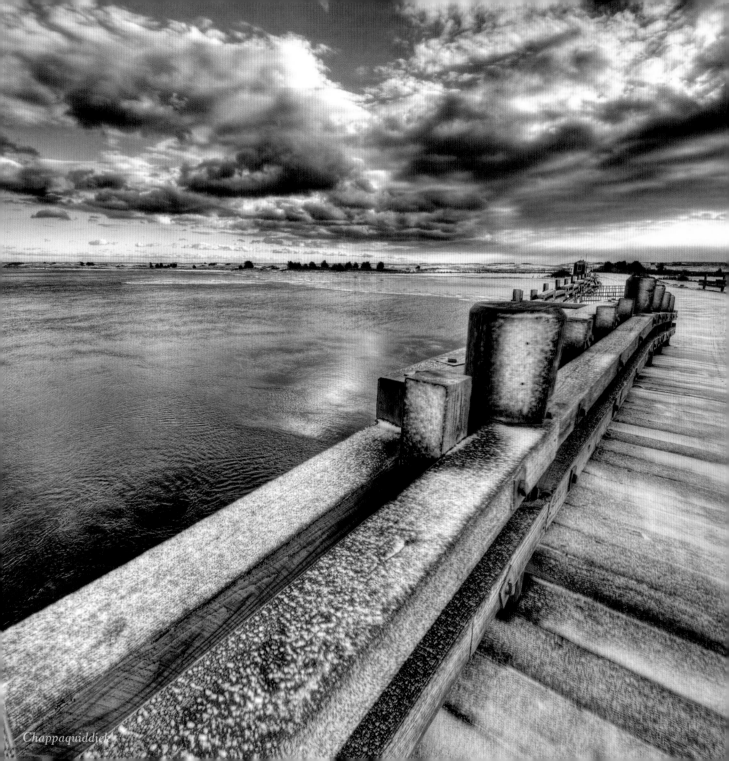

Chappaquiddick

Lessons Learned

MY PHOTOGRAPHS ARE NOT just pretty pictures. They are reminders to me of where I was when I took them, the hope that was in my heart, and how I want to continue living my life—sober, serene, honest.

What follows on these pages are my own personal lessons, the things I have found important as I continue fighting for my life. I hope they will mean something to you, too.

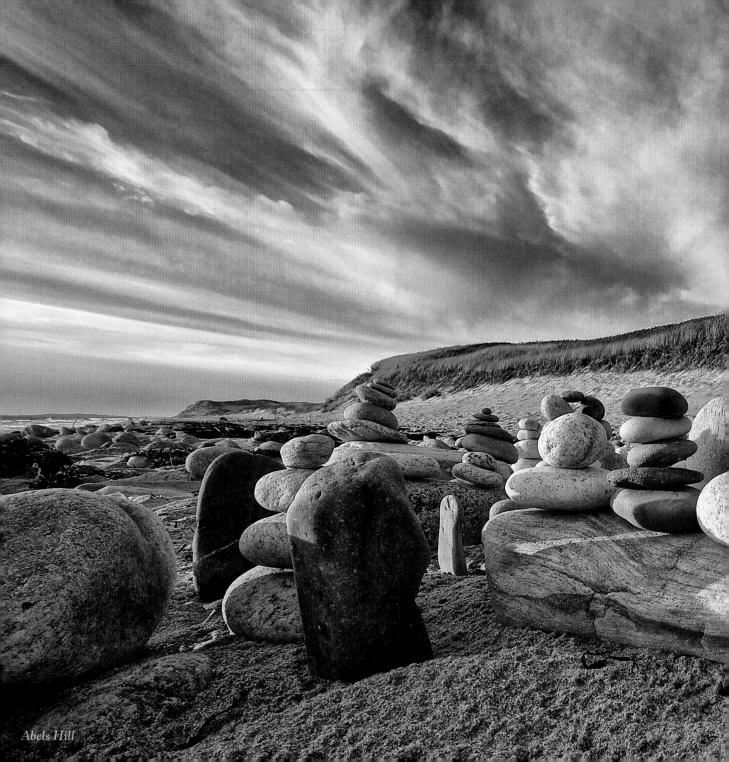

Abels Hill

FINDING COMMUNITY

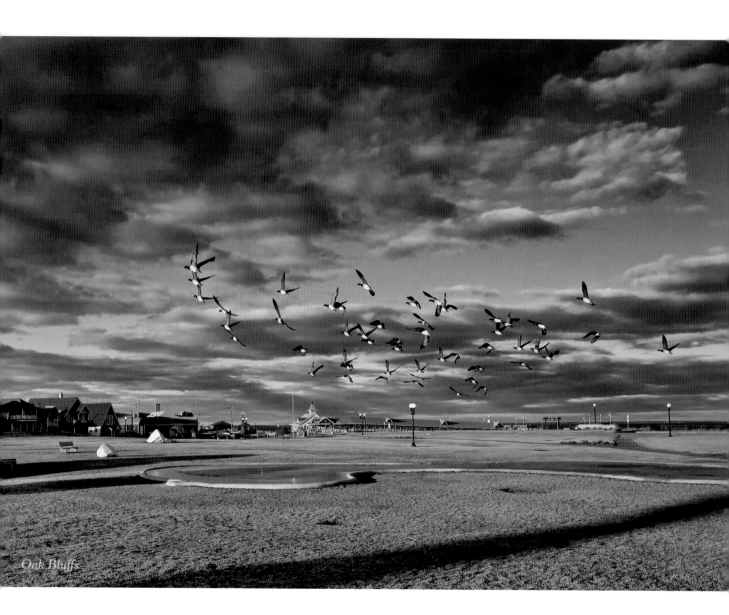

Oak Bluffs

FIGHTING FOR MY LIFE

~ 28 ~

I ONCE READ THIS QUOTE: "People spend a lifetime searching for happiness; looking for peace. They chase idle dreams, addictions, religions, even other people, hoping to fill the emptiness that plagues them. The irony is the only place they ever needed to search was within." While I found this quote enlightening, I also learned true meaning comes from engaging in community and the richness that comes from friendships.

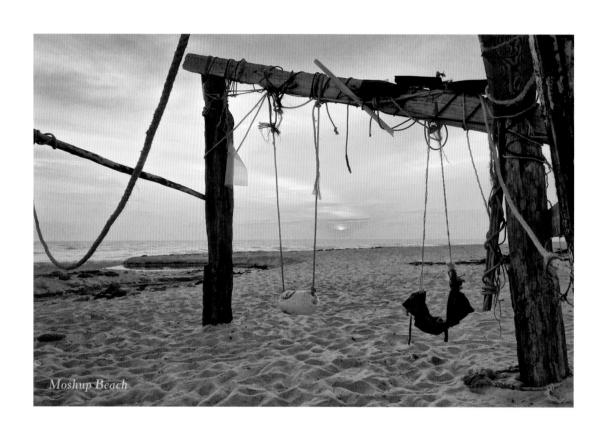

Moshup Beach

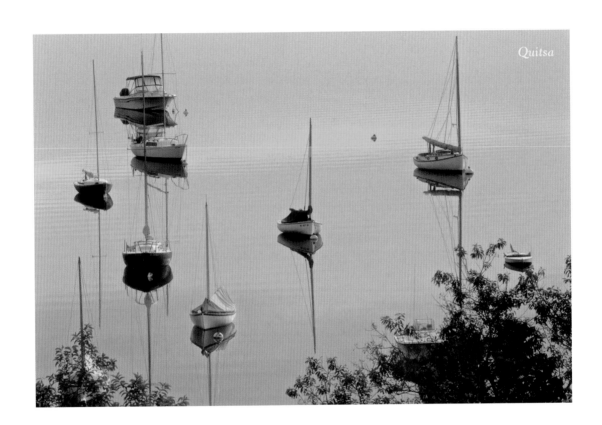

Quitsa

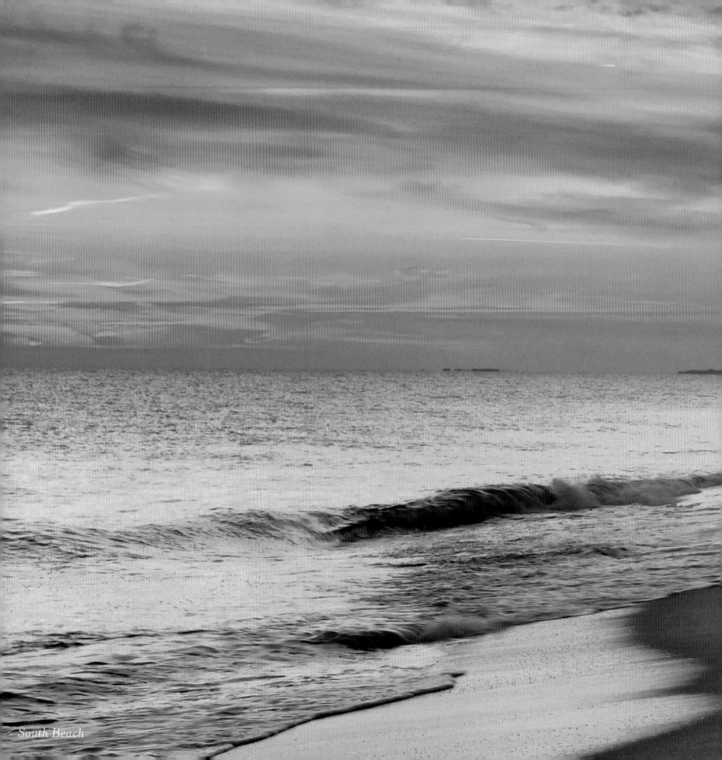

South Beach

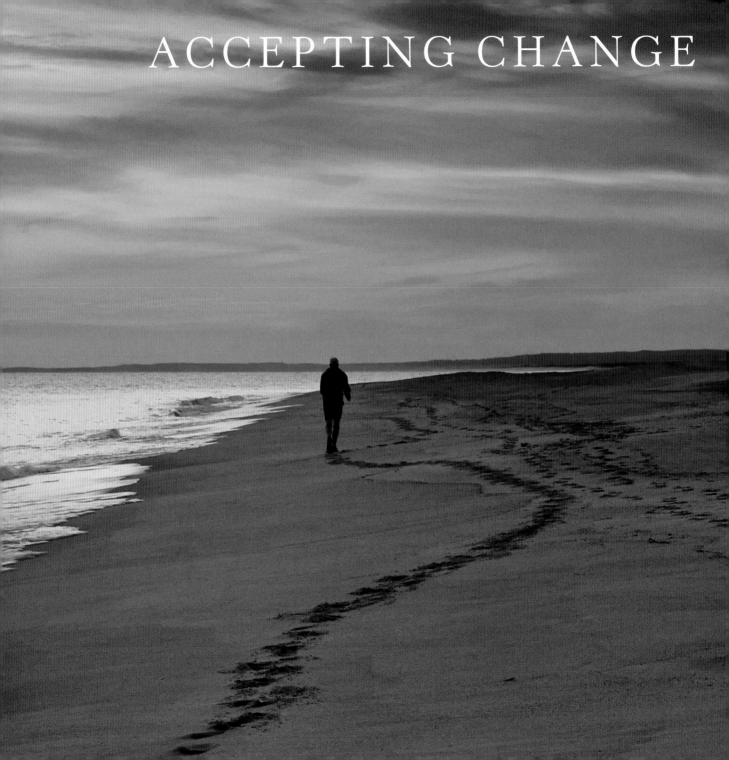

ACCEPTING CHANGE

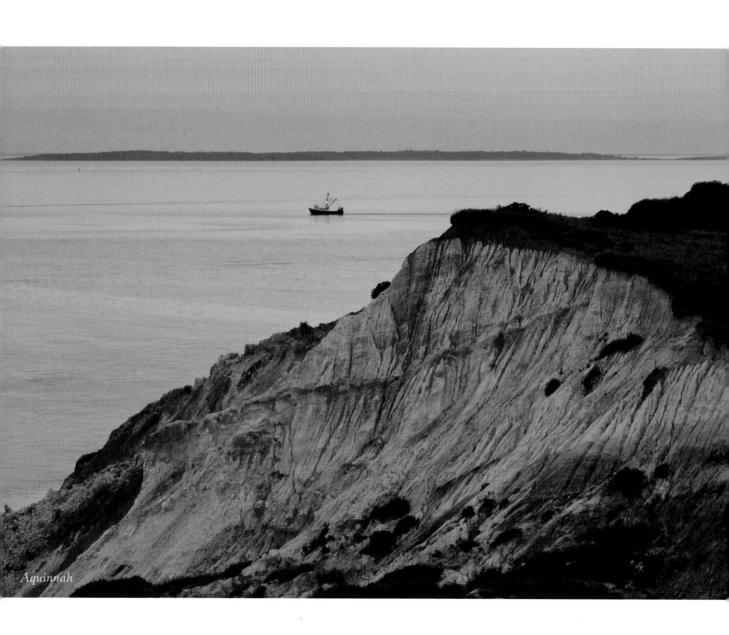

Aquinnah

Henry David Thoreau proposes in *Walden,* "The mass of men lead lives of quiet desperation." We pass through stages from childhood to competition and finally to reflection and wisdom. Would we change and become complete if we knew we would live forever? Is it possible we could forgive others and ourselves knowing mistakes are necessary in becoming an old and beautiful soul? Change is inevitable, participation is optional.

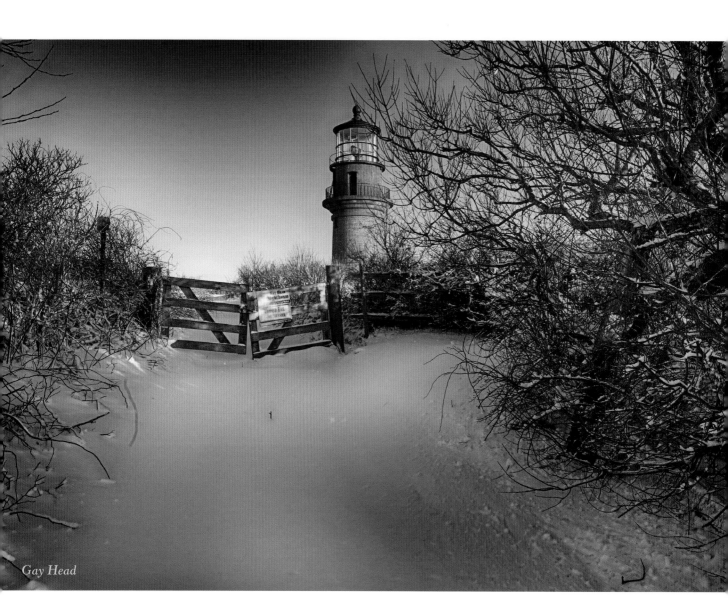

Gay Head

FIGHTING FOR MY LIFE

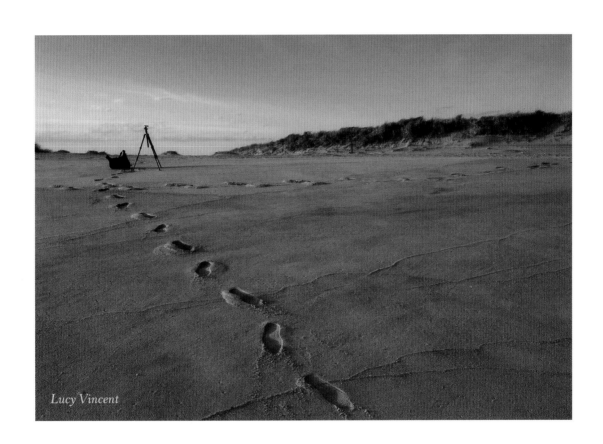

Lucy Vincent

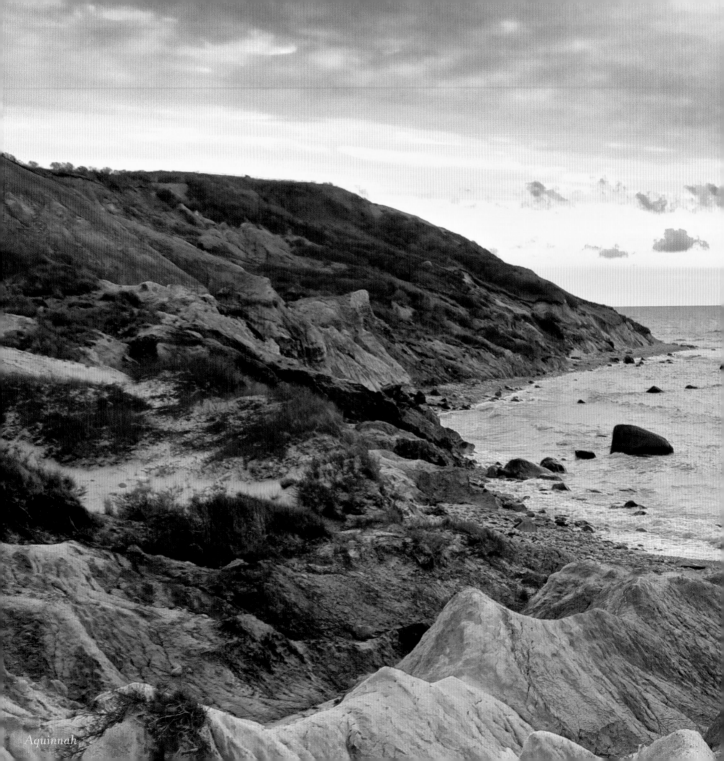

Aquinnah

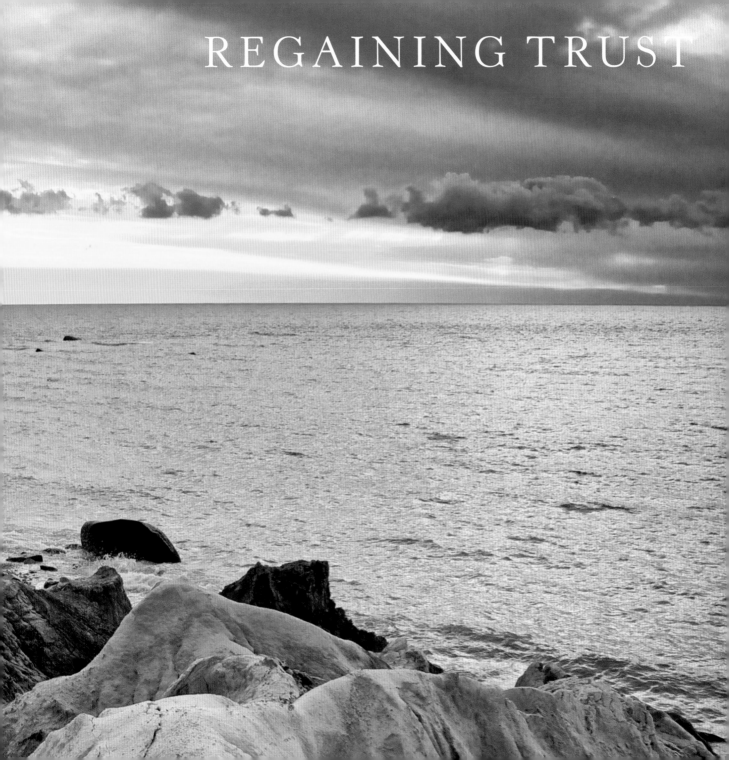

REGAINING TRUST

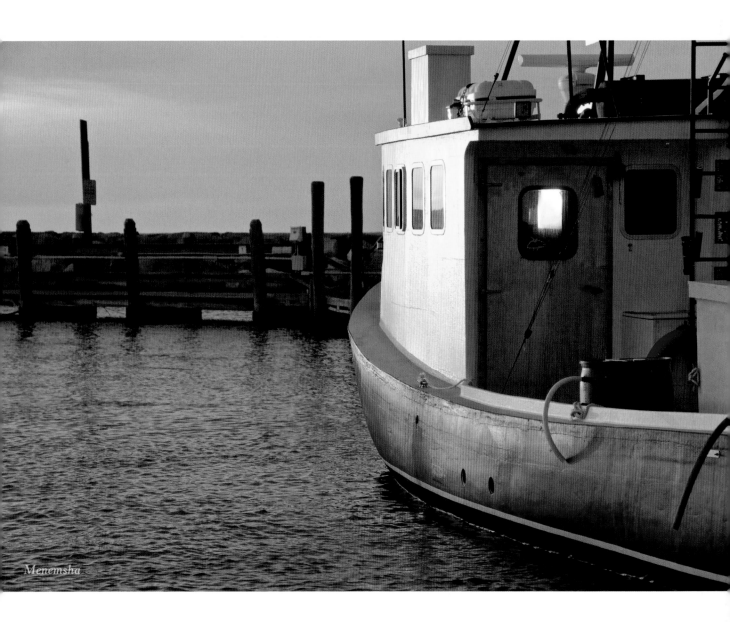

Menemsha

S TEP 1—MAKE A DECISION on whether you are prepared to make the effort for an extended period of time. Step 2—listen and feel the pain of those you hurt. Step 3—do not defend old positions that created the hurt—just listen. Step 4—consistently do the next right thing. Step 5—tell no lies of any kind; there is no room for niceties. If you happen to insult someone with your honesty, it will accelerate their faith that you are truthful. Finally—Wait for the time of healing to pass—which could be years.

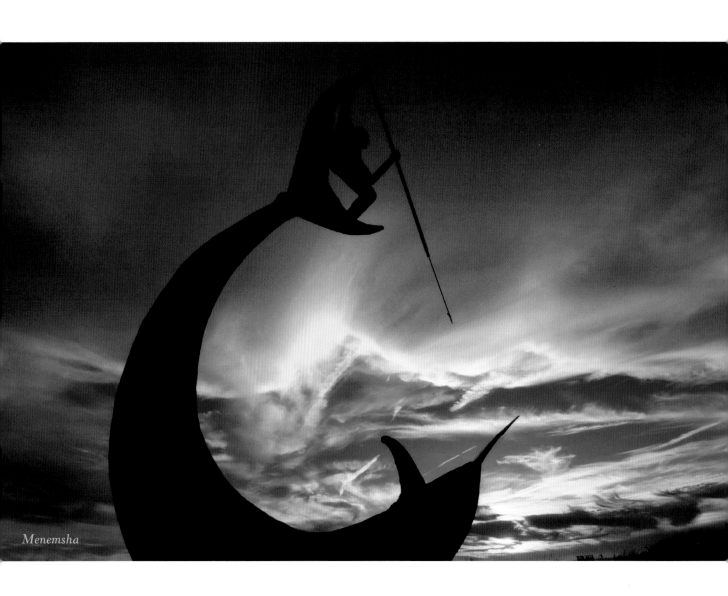

Menemsha

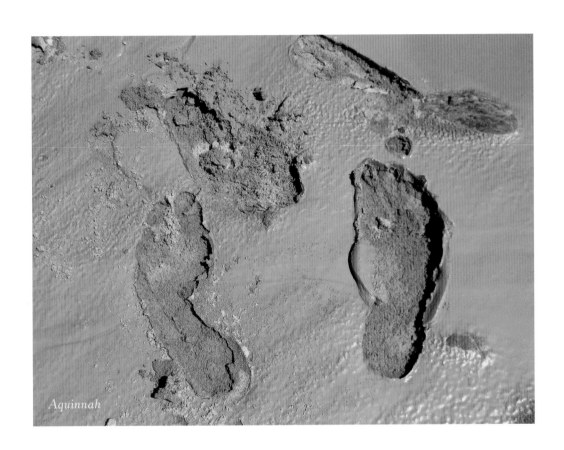

Aquinnah

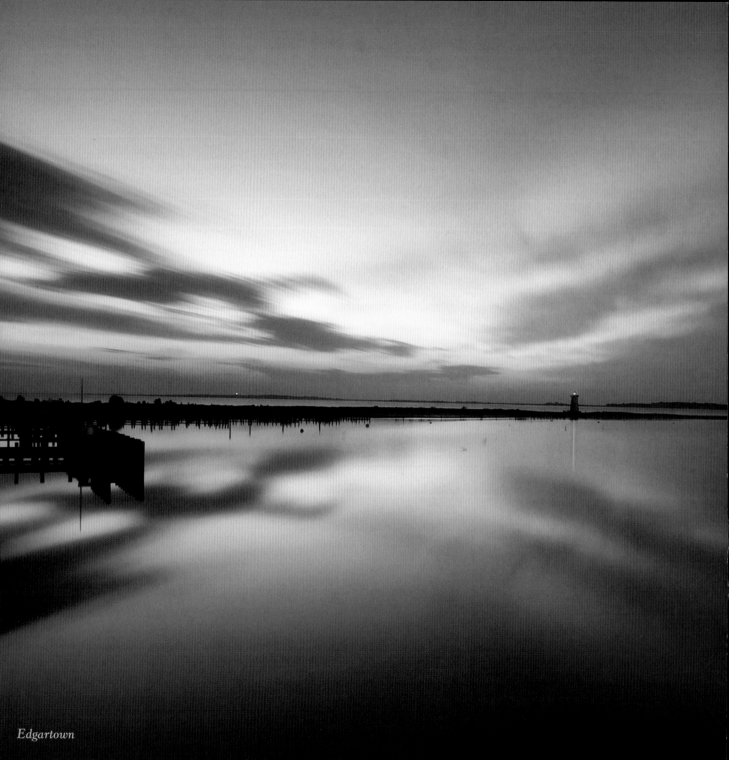

Edgartown

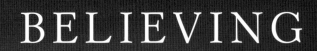

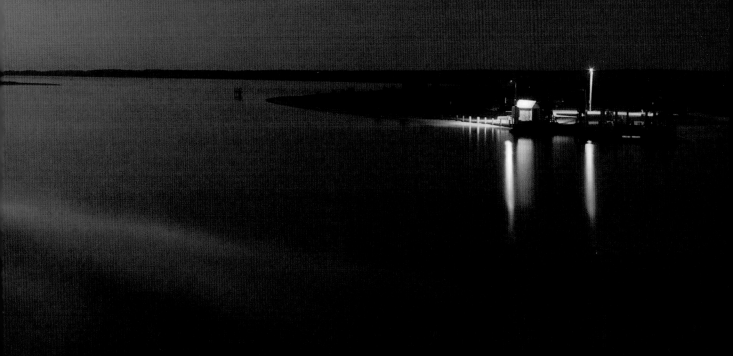

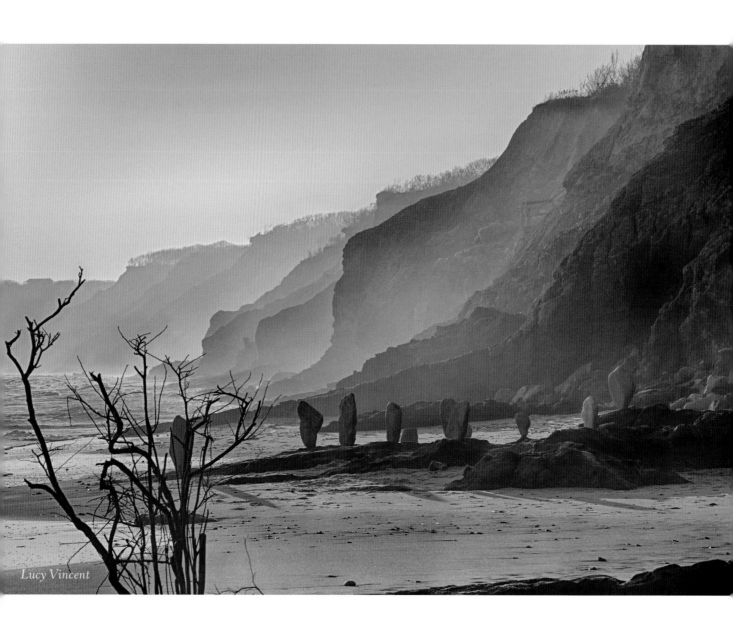

Lucy Vincent

FIGHTING FOR MY LIFE

~ 46 ~

LESSON 4

MANY FOLKS IN RECOVERY have difficulty with religious-based programs or groups that contemplate "spirituality" in their doctrines. When I sit on the cliffs of Lucy Vincent or Gay Head an hour before sunrise, I feel bathed in spiritual energy I can't understand. Knowing I am part of something larger helps me let go of isolation and moves me to community where I can love and be loved. Life is more than who we are.

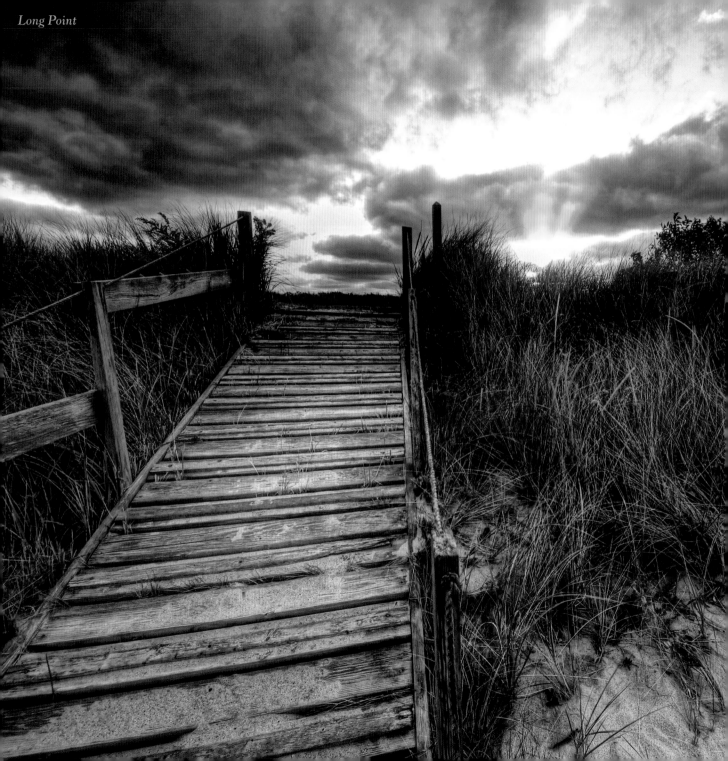

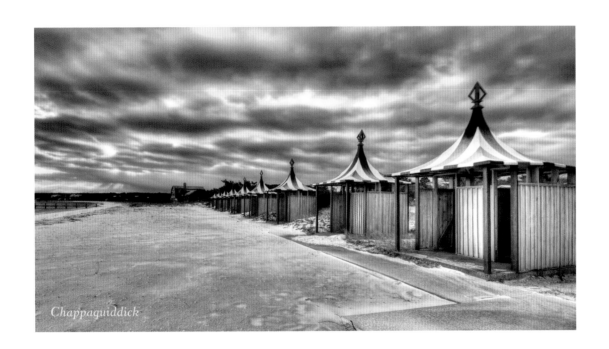

Chappaquiddick

FINDING HOPE AND SERENITY ON MARTHA'S VINEYARD

~ 49 ~

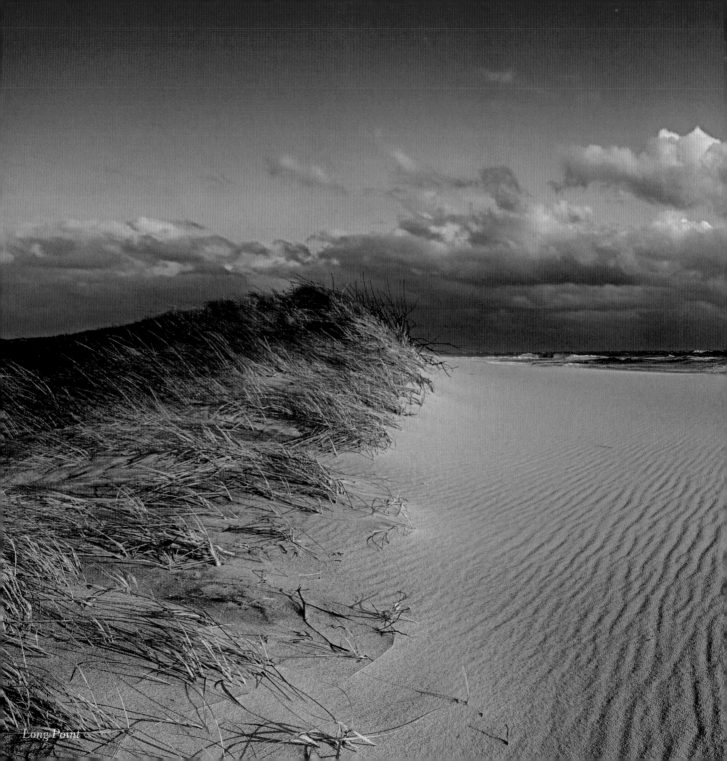

Long Point

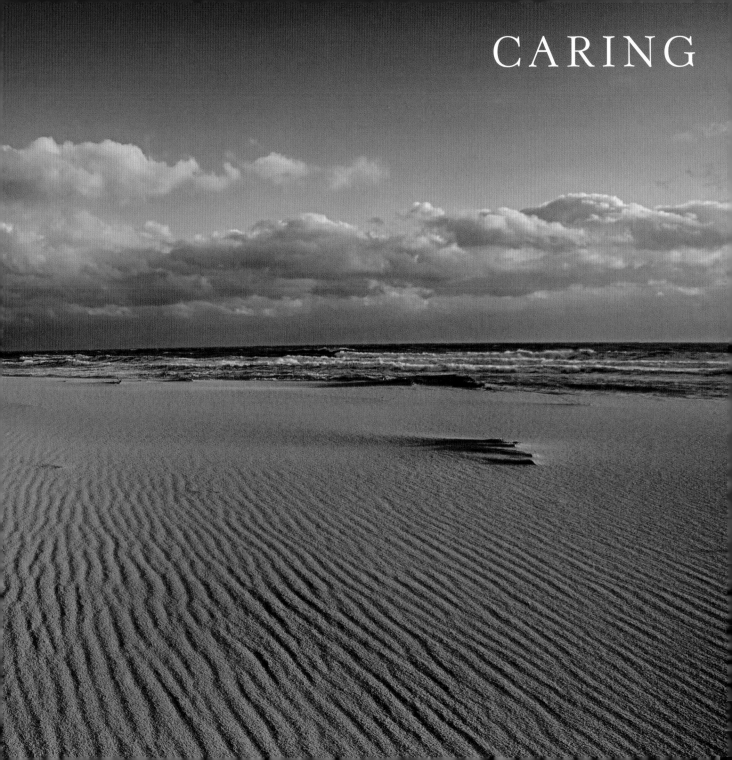

CARING

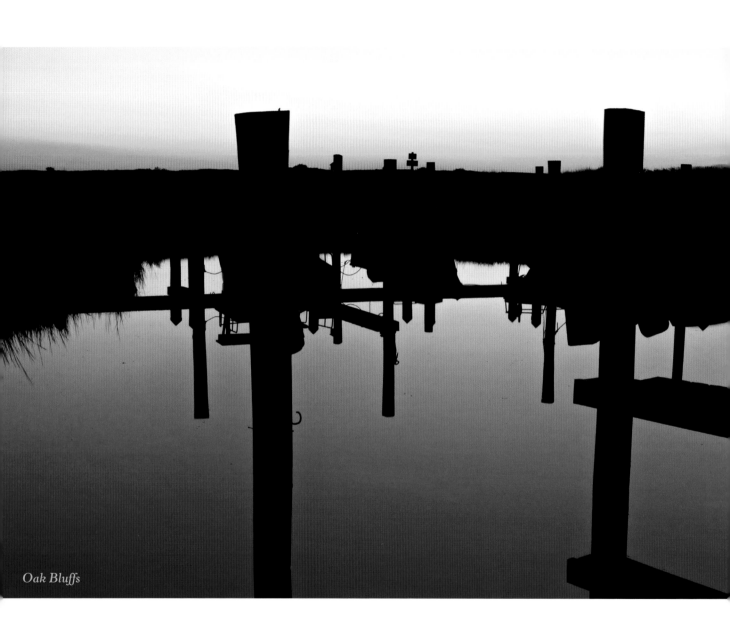

Oak Bluffs

LESSON 5

WHEN YOU ARE DOWN and out, people you would never expect will rise up to help. It will restore your faith in the goodness of people. Addiction, psychiatric disorders, and other maladies of the soul require isolation to fester. The afflicted judges the world as cruel and unkind. When we choose to let go of these misguided beliefs, we see this network of people who were there to help us all the time.

South Beach

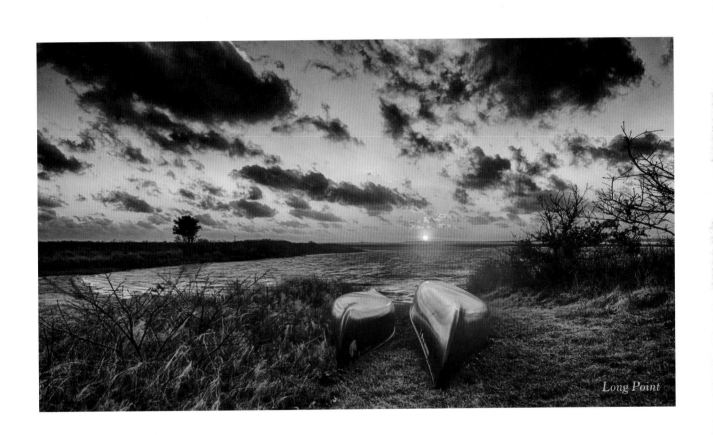

Long Point

FINDING HOPE AND SERENITY ON MARTHA'S VINEYARD

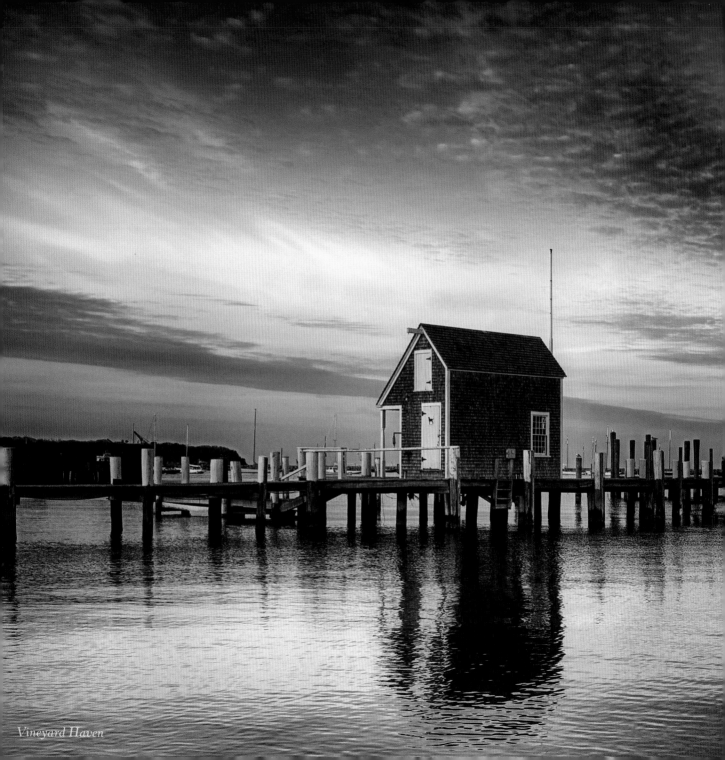

Vineyard Haven

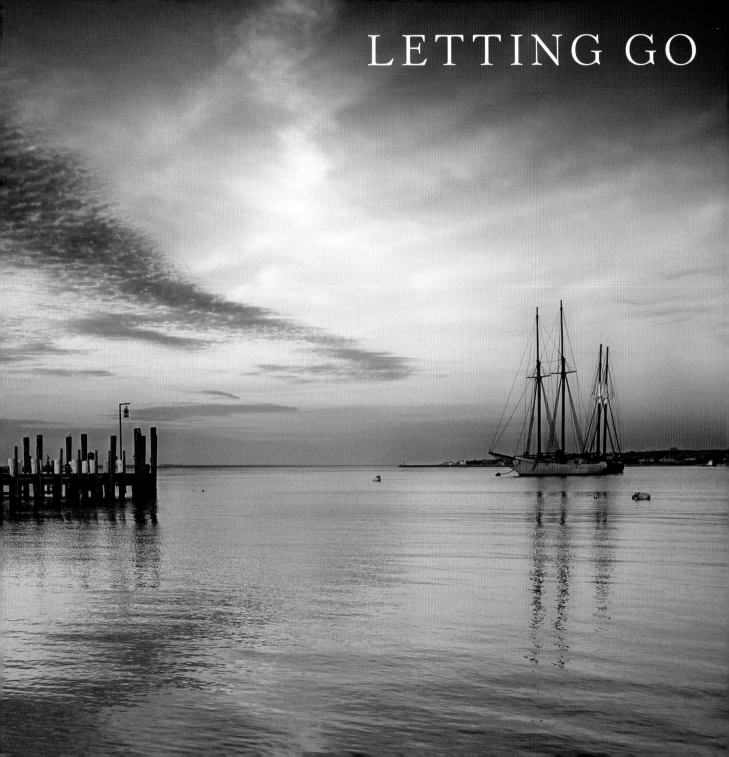

LETTING GO

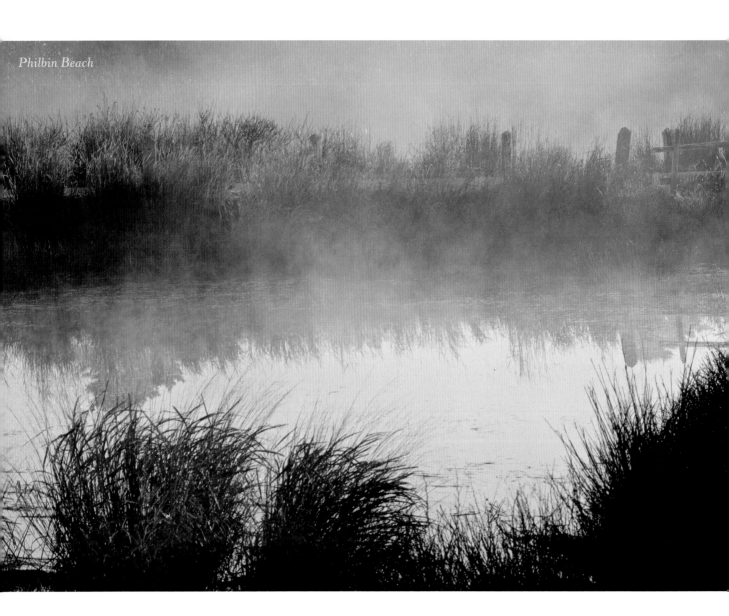

Philbin Beach

LESSON 6

PARENTS STRUGGLE WITH CHILDREN who are addicts or alcoholics and pay an emotional price of excruciating pain. Yet as Kahlil Gibran states in *The Prophet*, "Your children are not your children. They come through you but not from you, And though they are with you, yet they belong not to you." Letting go is a necessary strategy to keep the teacher healthy and ready for the moment the student is ready to listen.

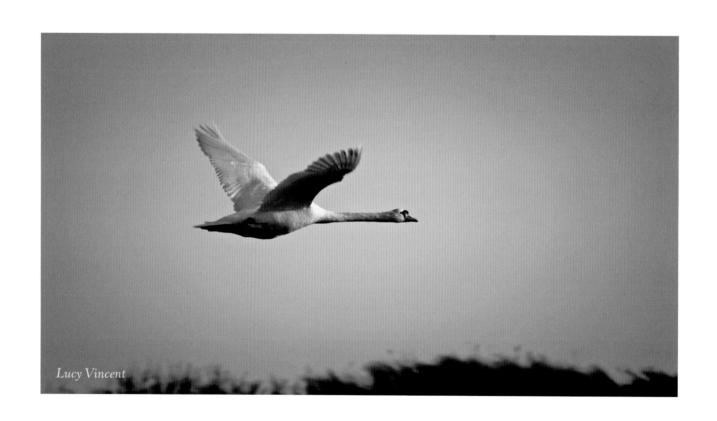

Lucy Vincent

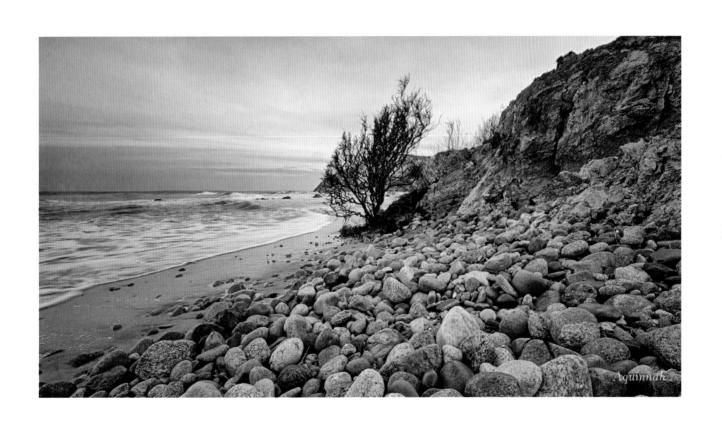

Aquinnah

FINDING HOPE AND SERENITY ON MARTHA'S VINEYARD

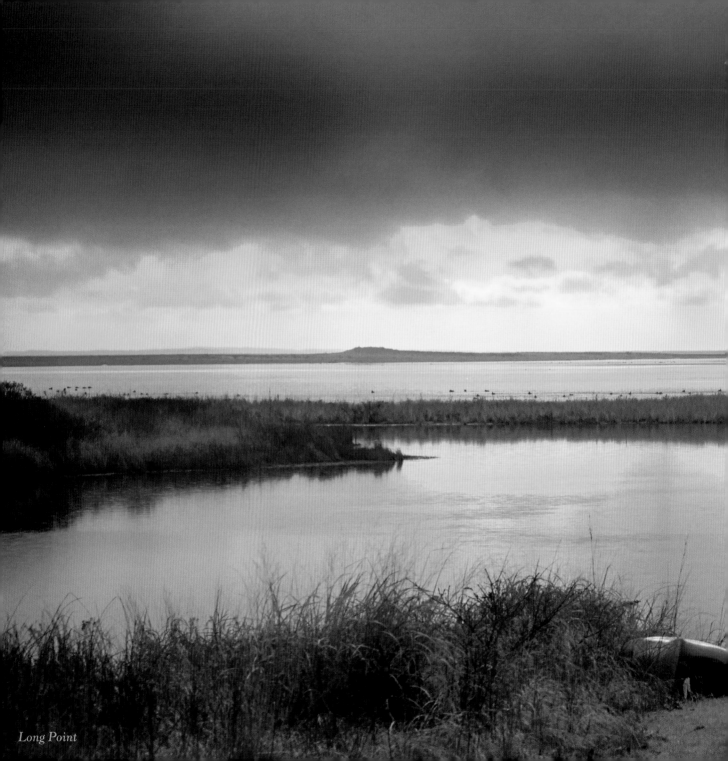

Long Point

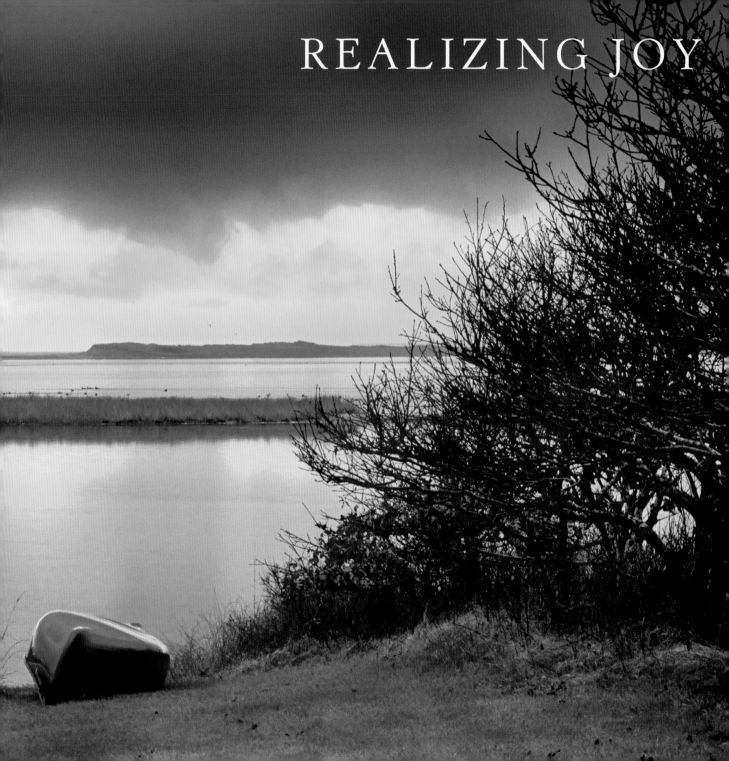

REALIZING JOY

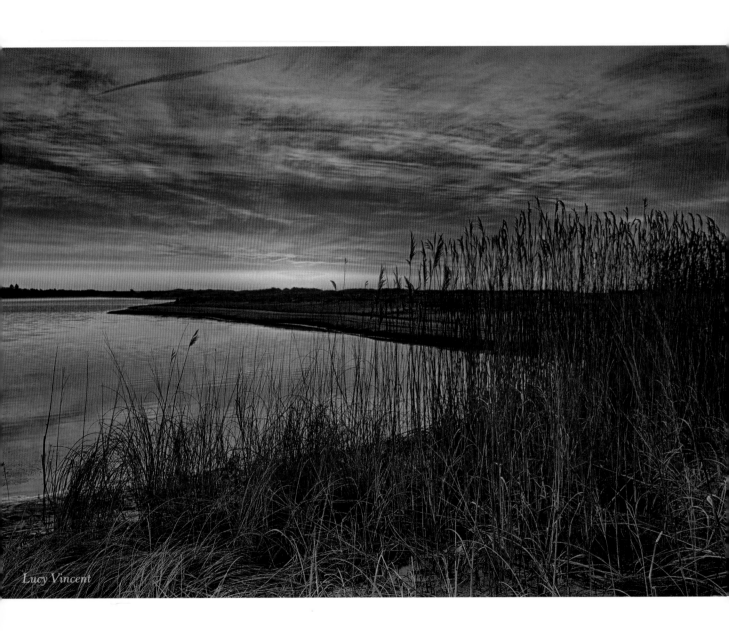

Lucy Vincent

FIGHTING FOR MY LIFE

FOR YEARS, IN THE DEPTHS of my addiction, I reasoned that children experience joy because they were never exposed to the amazing chemical effects of alcohol. I believed once the brain became exposed to this new euphoria, there could never be joy in its absence. I have learned that the truth is actually the opposite. Alcoholism is a joyless prison and happiness can never truly be experienced in its presence. Trust me.

West Tisbury

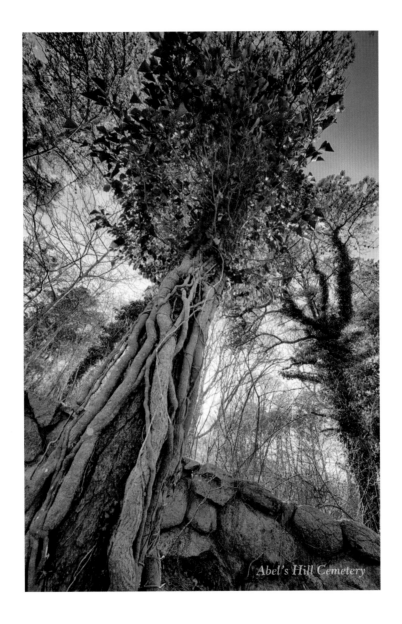

Abel's Hill Cemetery

FINDING HOPE AND SERENITY ON MARTHA'S VINEYARD

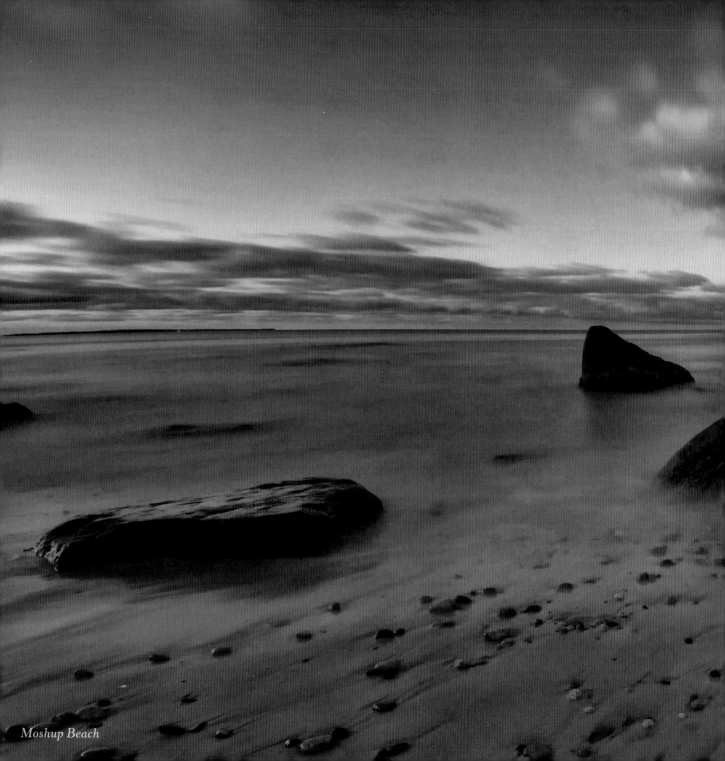

Moshup Beach

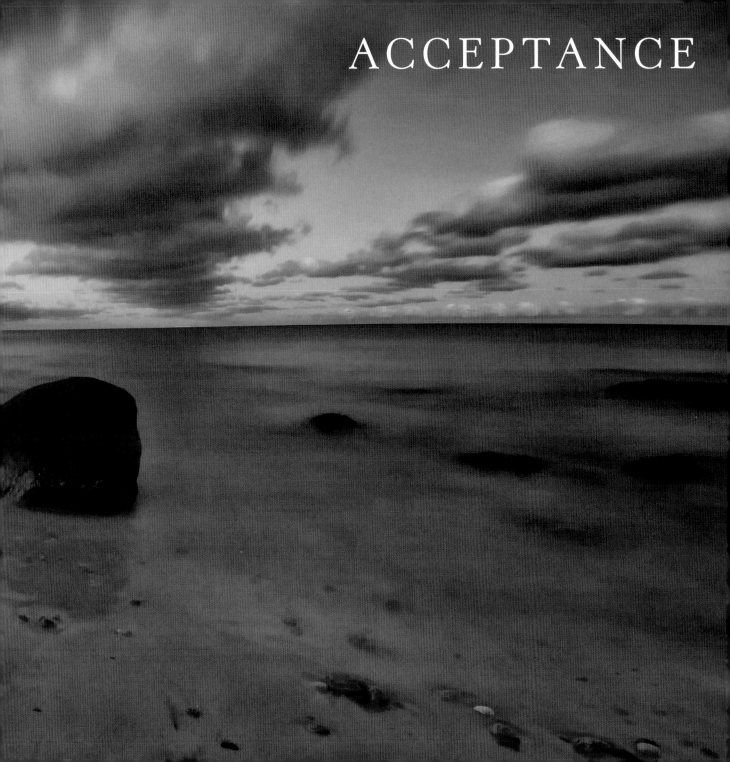

ACCEPTANCE

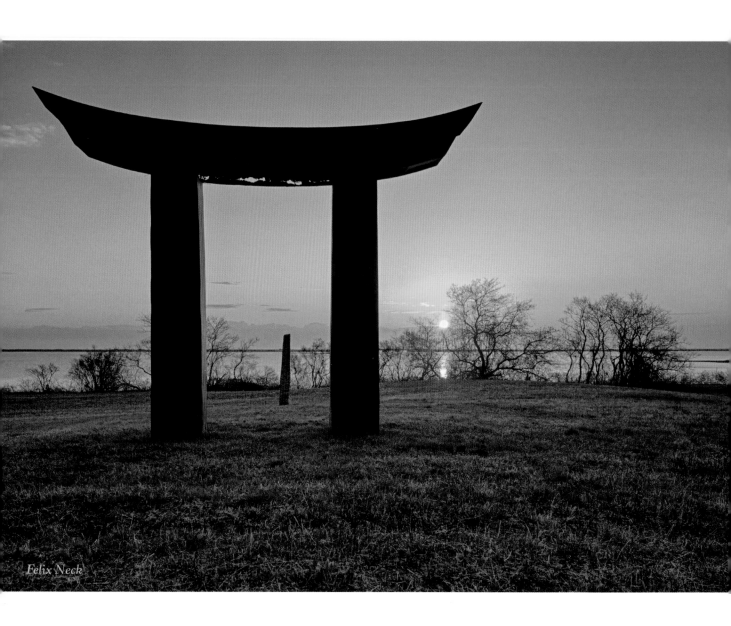

Felix Neck

FIGHTING FOR MY LIFE

LESSON 8

R EINHOLD NIEBUHR IS CREDITED with the serenity prayer used by recovery groups. *"God, grant me the serenity to accept the things I cannot change, the courage to change the things I can, and wisdom to know the difference."* With alcoholics and addicts, regrets and resentments are the most powerful motivators for relapse. Guilt and shame can be managed by consistently doing the next right thing. But be prepared to accept that others may never forgive—and to remain whole you must accept and let go. Without sobriety there is nothing.

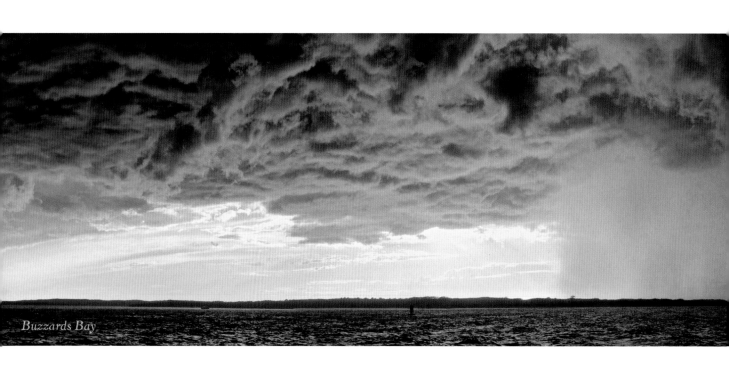

Buzzards Bay

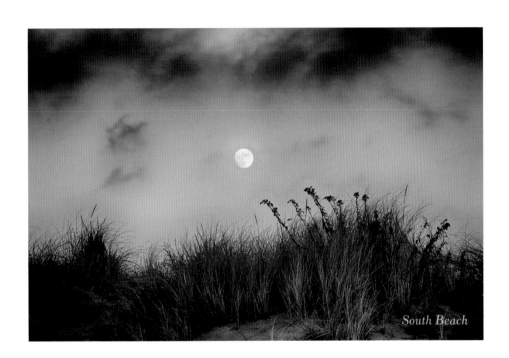

South Beach

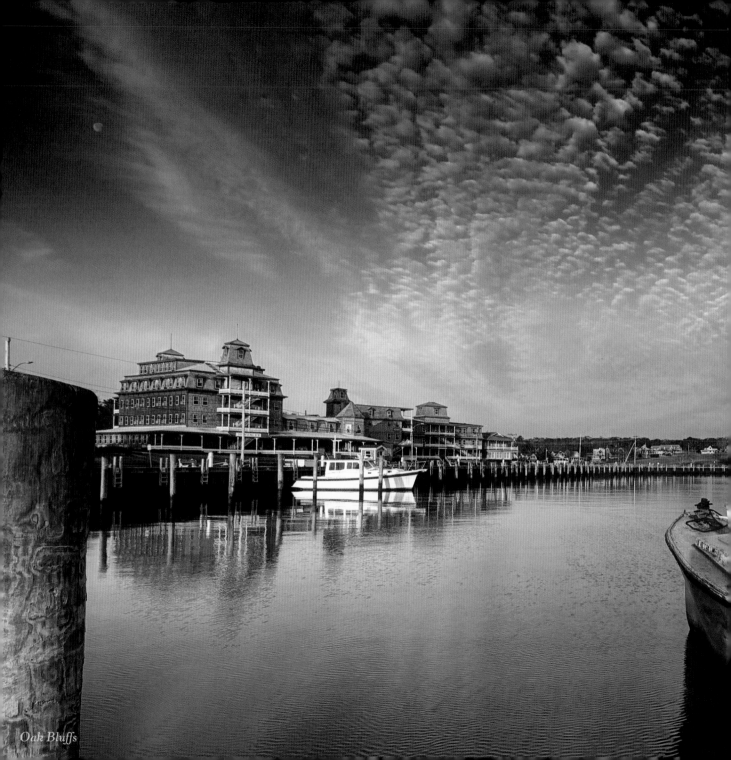

Oak Bluffs

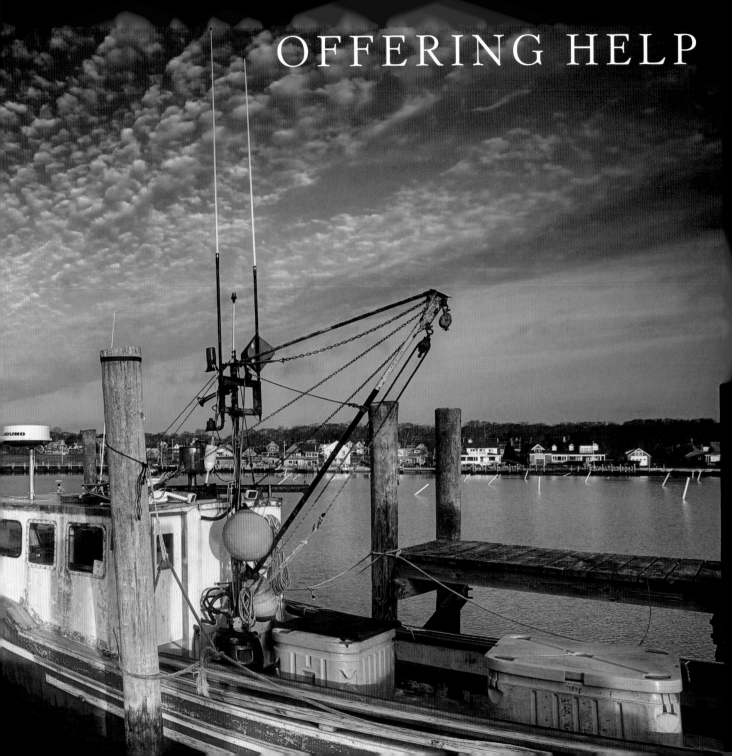

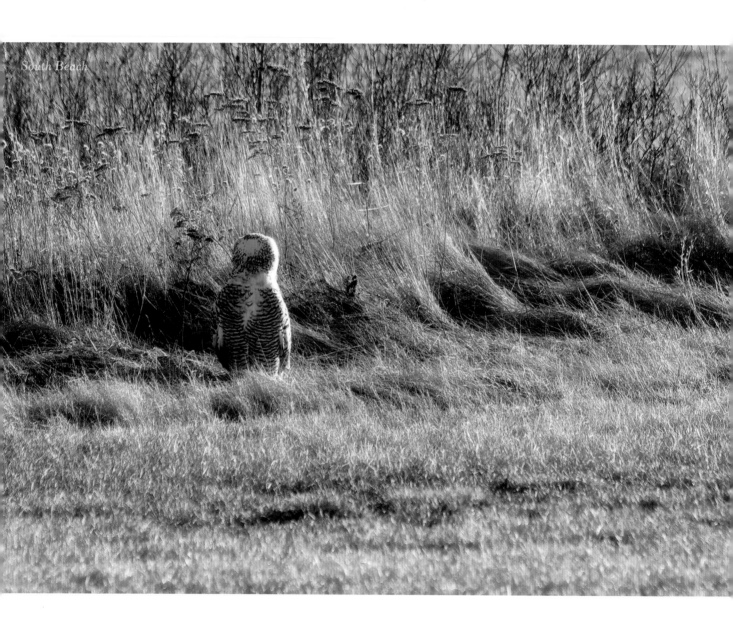

South Beach

I CAN'T EMPHASIZE ENOUGH, the act of helping others as wounded as yourself is healing and liberating. This Chinese proverb says it best: "If you want happiness for an hour, take a nap. If you want happiness for a day, go fishing. If you want happiness for a month, get married. If you want happiness for a year, inherit a fortune. If you want happiness for a lifetime, help somebody else."

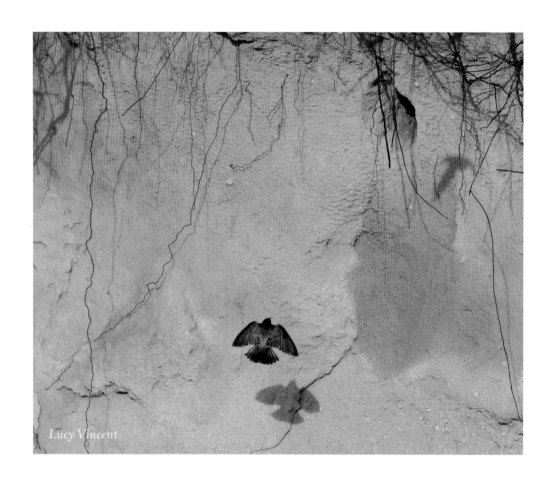

Lucy Vincent

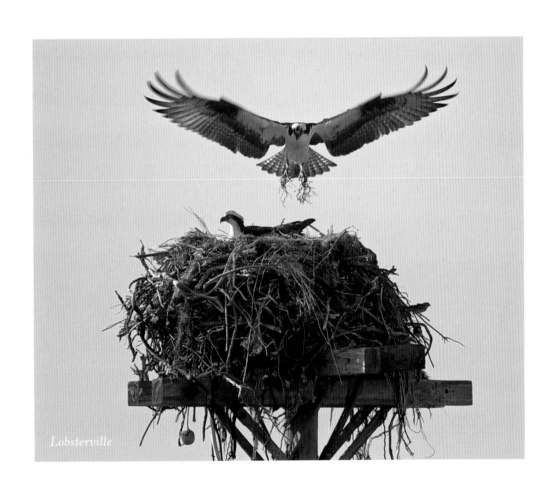

Lobsterville

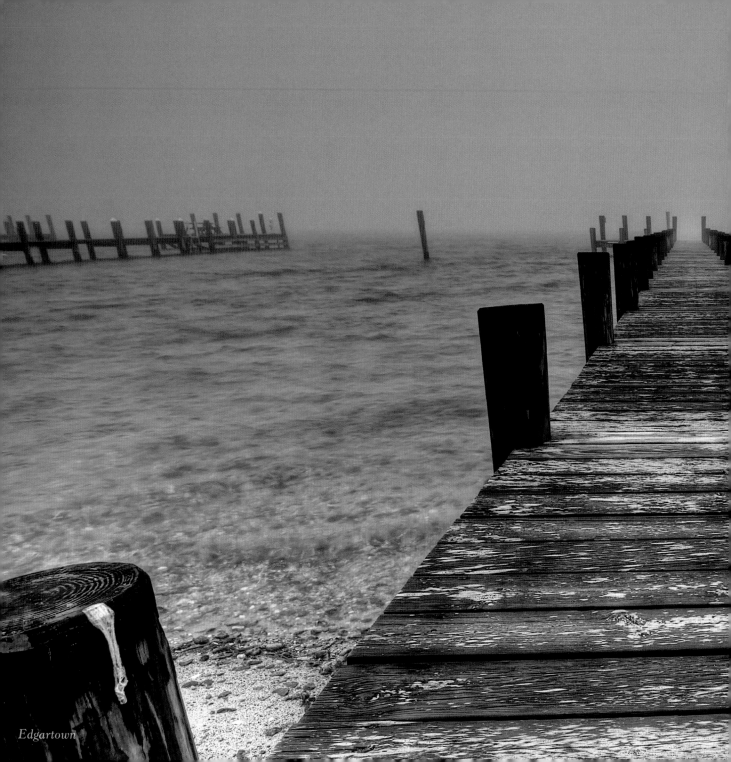

Edgartown

ONE DAY AT A TIME

Philbin Beach

ONE DAY AT A TIME—such a cliche. If you forced me to read this book five years ago and I surmised the complexity and pain of what I had to go through to be happy, I would immediately drink a quart bottle of vodka! Way too intimidating taken as a whole. But life deserves to be lived minute to minute— the path is not supposed to be clear. You must trust that when you consistently do the next right thing, tell no lies and show love and kindness, any adversity *will* be overcome.

Menemsha Hills Reservation

FIGHTING FOR MY LIFE

~ 84 ~

State Beach

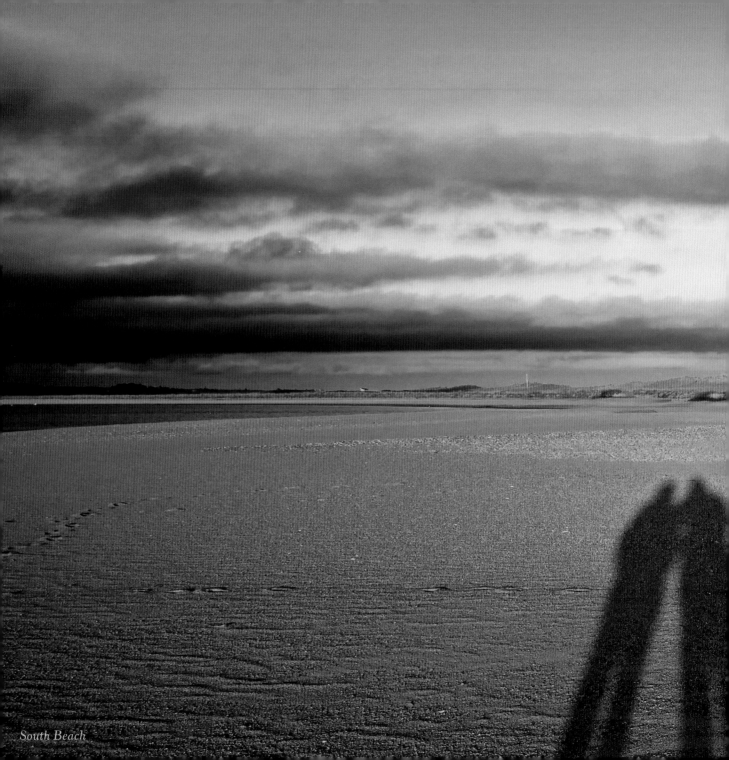

South Beach

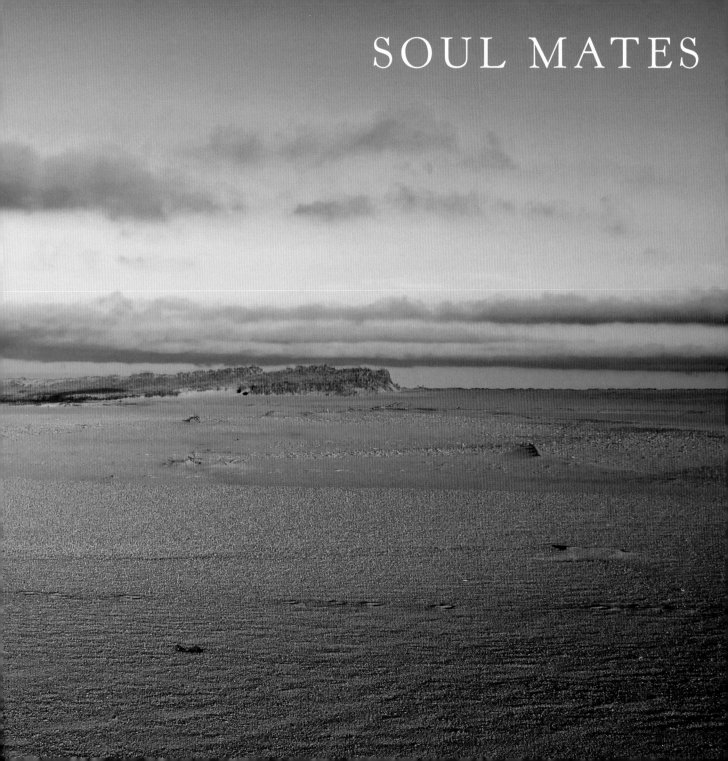

SOUL MATES

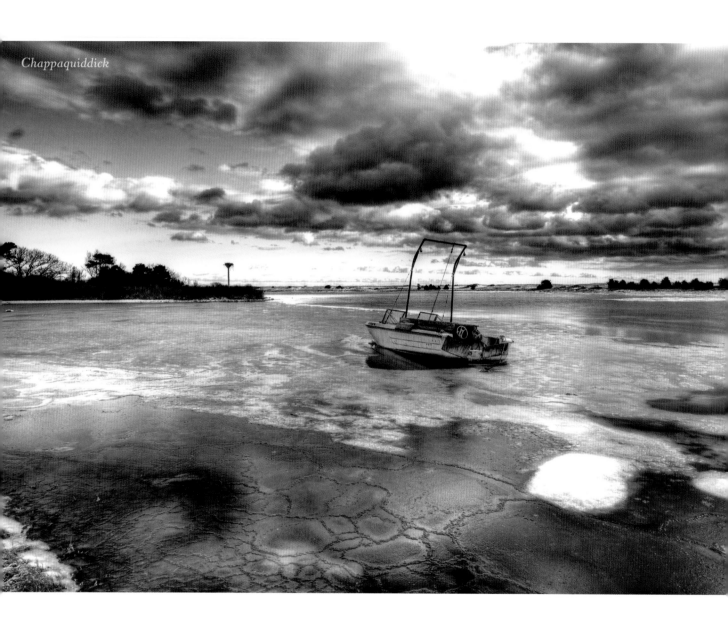

Chappaquiddick

THE MOST ACCURATE AND beautiful description of a true soul mate is probably this description: "Certainly a soul mate can be a life-long lover and partner. But not always. Sometimes our soul mate relationships are the most painful we'll ever experience." It's important to see that whatever pain a soul mate causes you, it is done to help you with the growth of your soul. It's to open your eyes to realizing that this person is just a reflection back to you of what is inside yourself.

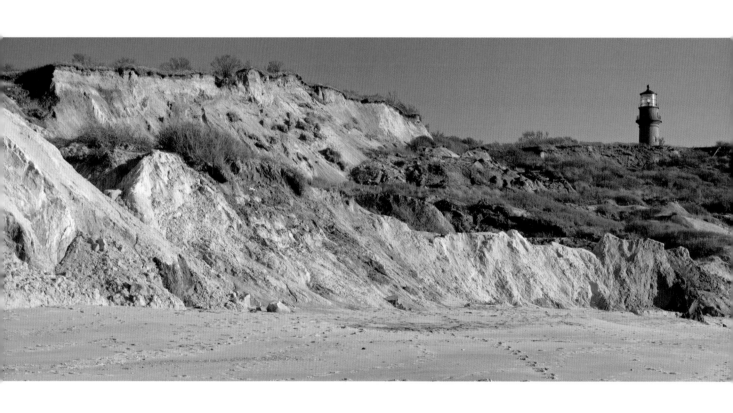

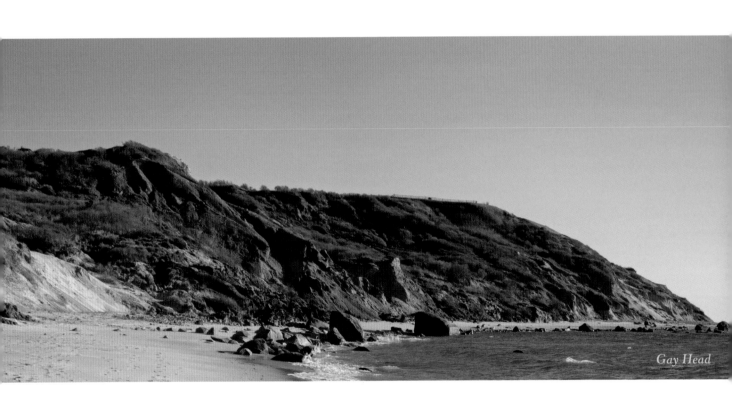

Gay Head

FINDING HOPE AND SERENITY ON MARTHA'S VINEYARD

~ *91* ~

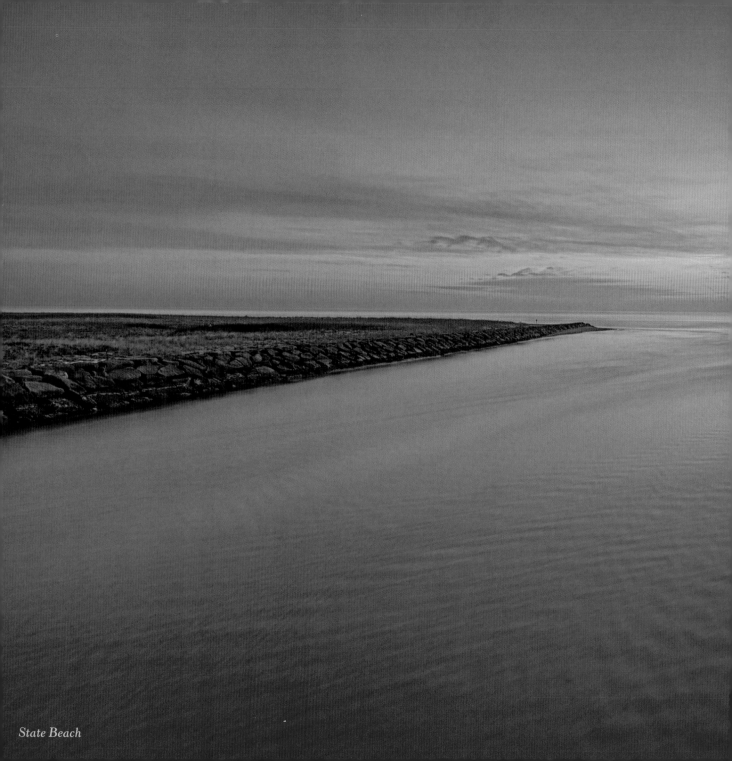
State Beach

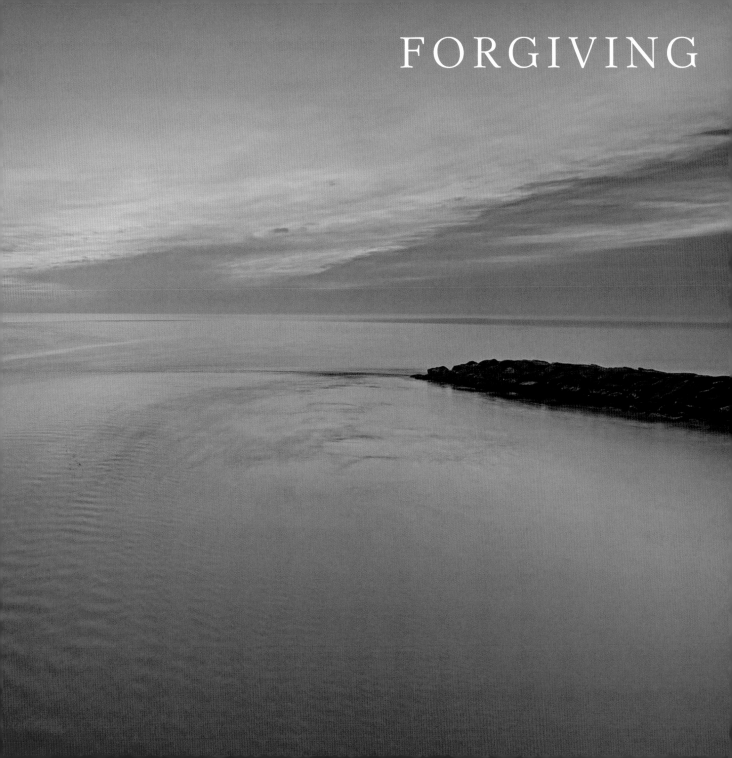

FORGIVING

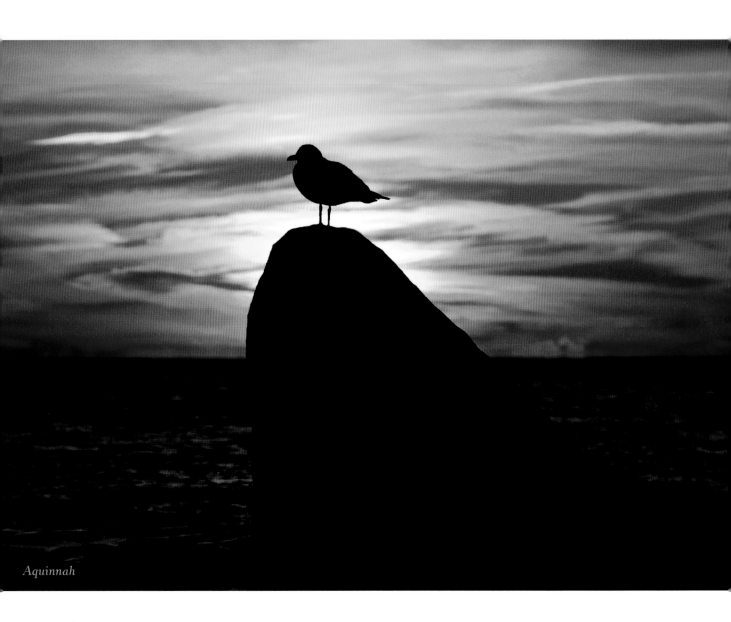

Aquinnah

FIGHTING FOR MY LIFE

LESSON 12

FORGIVENESS ISN'T FORGETTING the wrong that was committed or condoning the action. Instead, it is allowing for the possibility that change is truly possible and individuals are capable of earning a second chance. I learned that words mean nothing when repairing damage. Hurt takes time to heal and can only be accomplished through brutal honesty and consistently doing the next right thing. Forgiveness has the benefit of liberating the afflicted and setting oneself free to move forward.

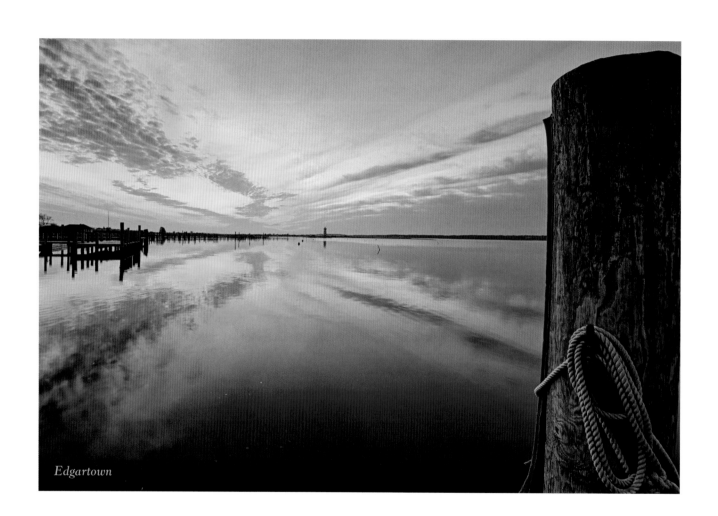

Edgartown

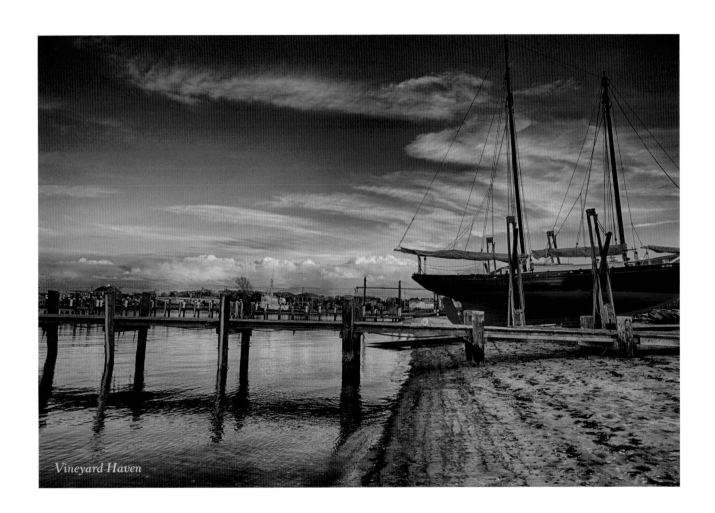

Vineyard Haven

FINDING HOPE AND SERENITY ON MARTHA'S VINEYARD

~ 97 ~

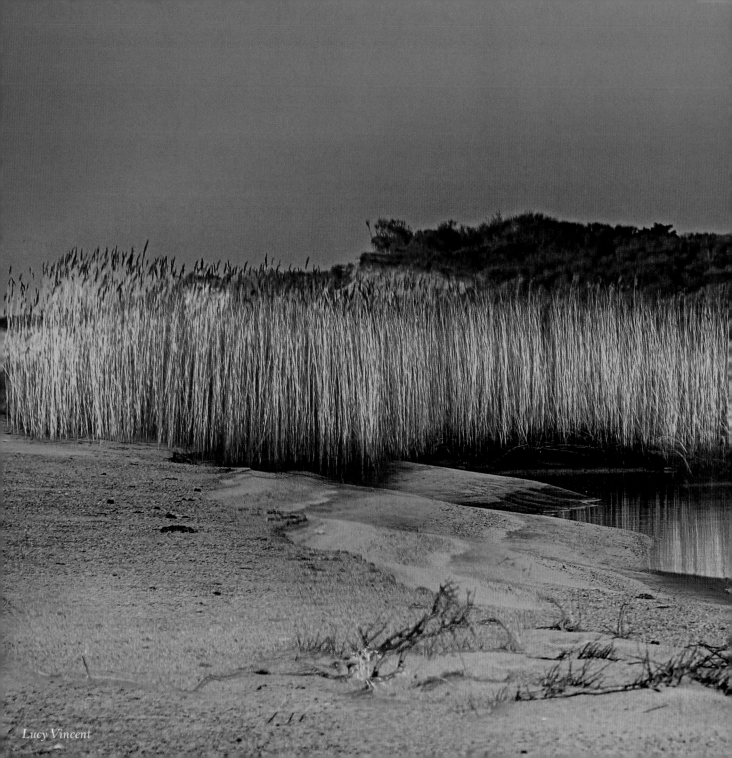

Lucy Vincent

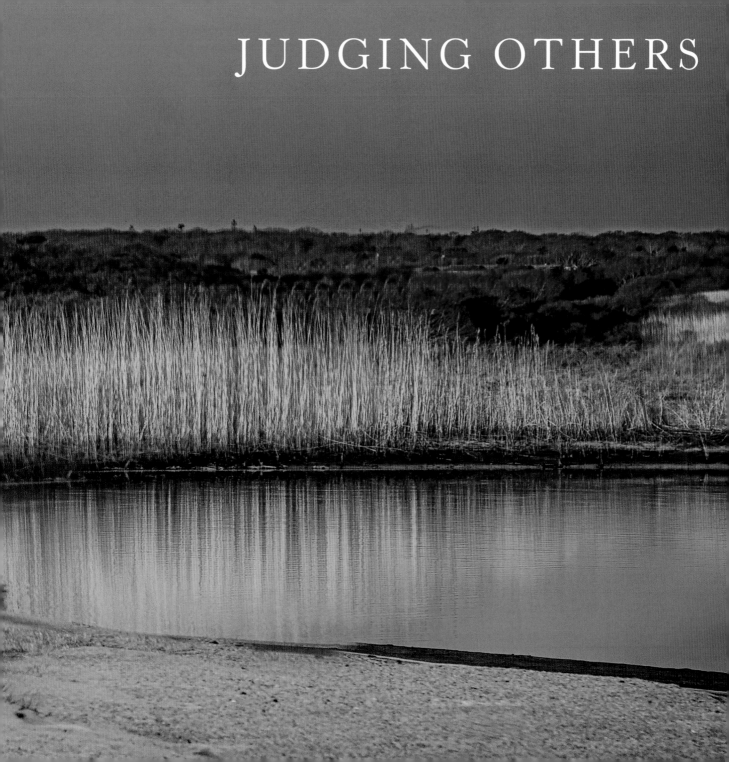

JUDGING OTHERS

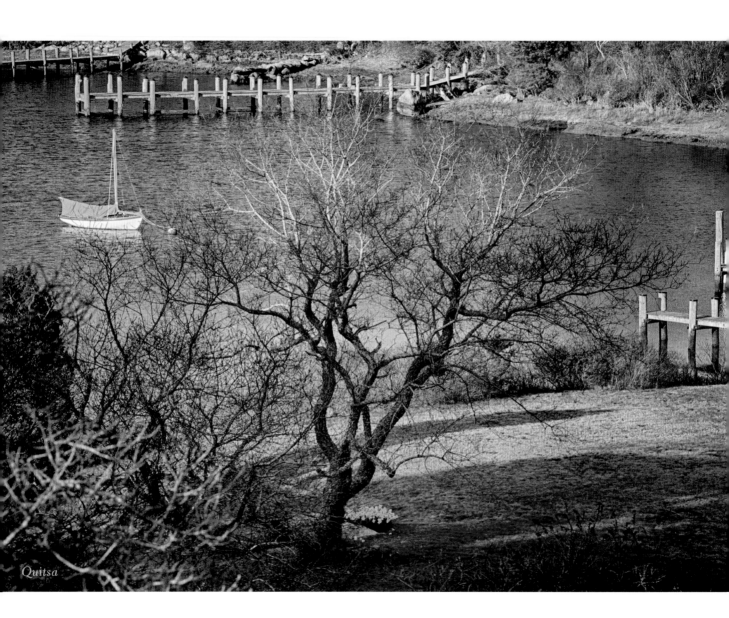

Quitsa

A N EARLY GREEK PHILOSOPHER was once quoted as saying, "Be kind to every person you meet, for they are fighting a hard battle." I learned individuals should not be judged at any one step on life's path but rather for the person they become. Would you feel differently about an alcoholic sleeping on a park bench if you knew he had just poured several bottles of vodka down the drain in a desperate attempt to stop? What gives us the right to judge? Be kind.

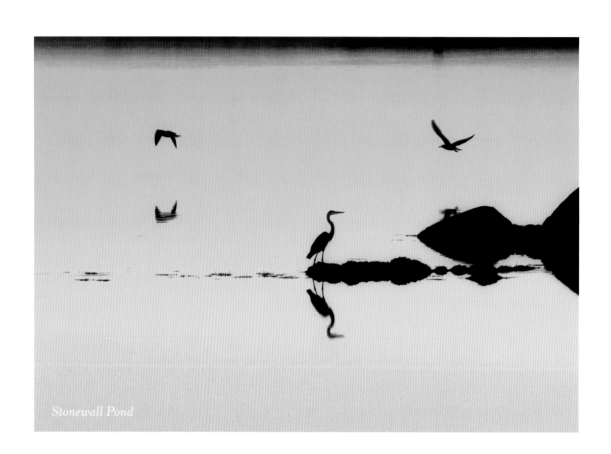

Stonewall Pond

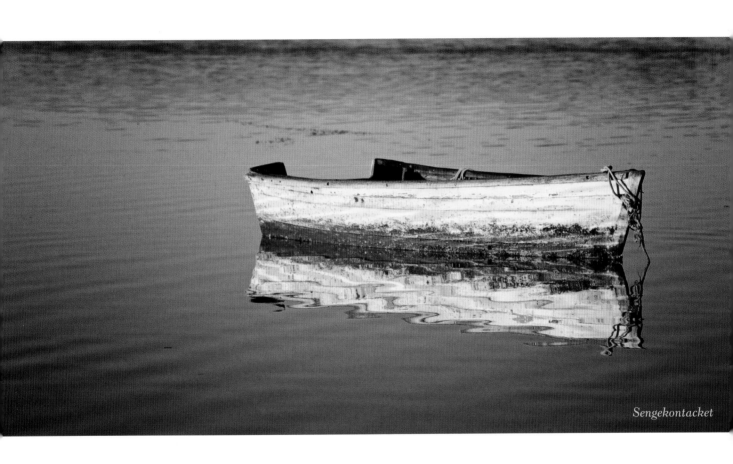

Sengekontacket

FINDING HOPE AND SERENITY ON MARTHA'S VINEYARD

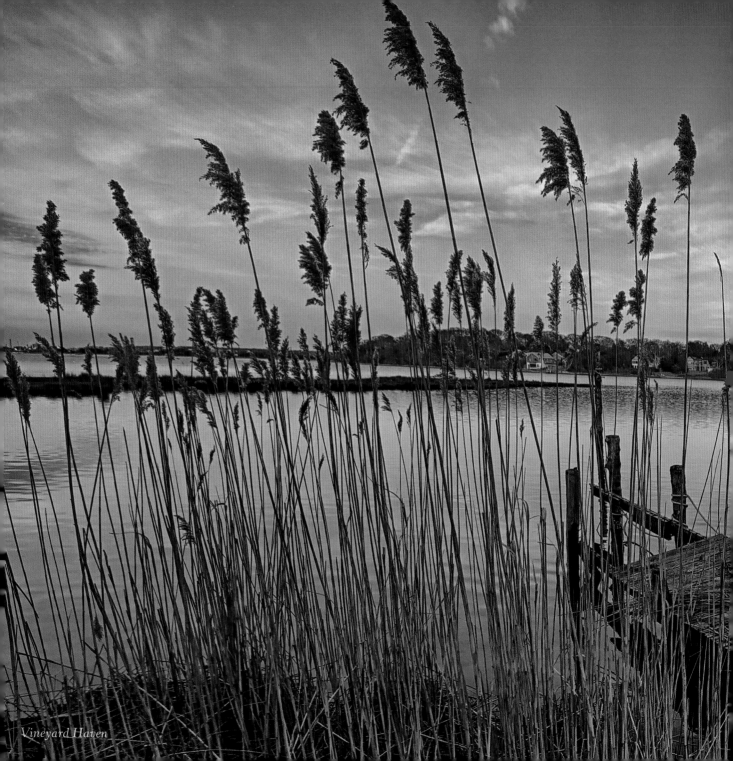

Vineyard Haven

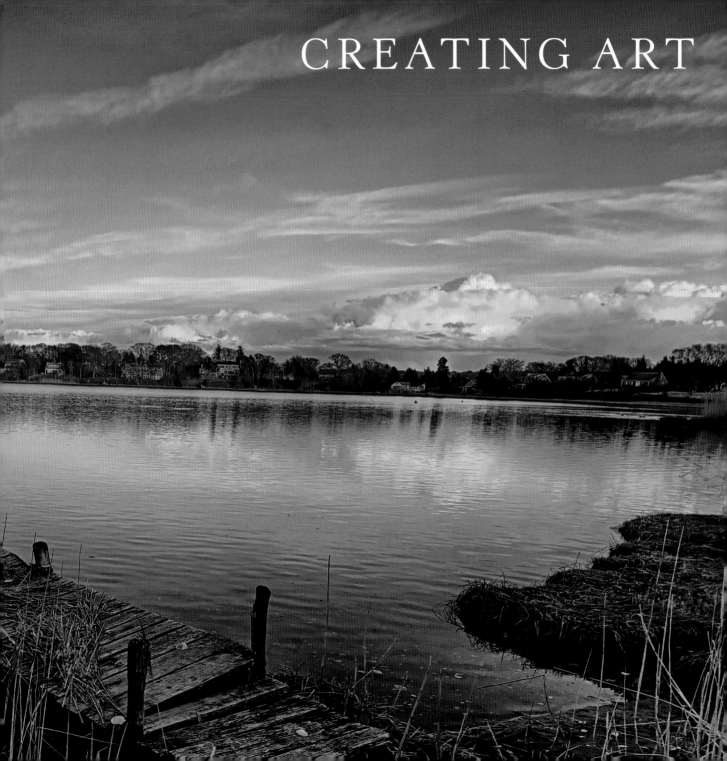
CREATING ART

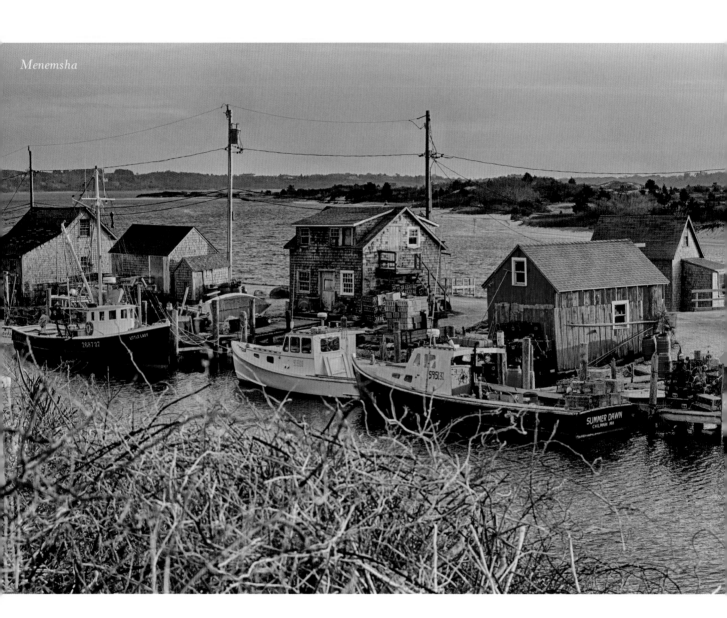

Menemsha

THE ART OF EDITING photos gives me a feeling of joy that literally replaces the need for alcohol. When I feel stress, pain, and confusion, I escape to a place of beauty and creative expression—sitting in front of my computer. Ansell Adams once said, "Photographs are made, not taken." I understand why.

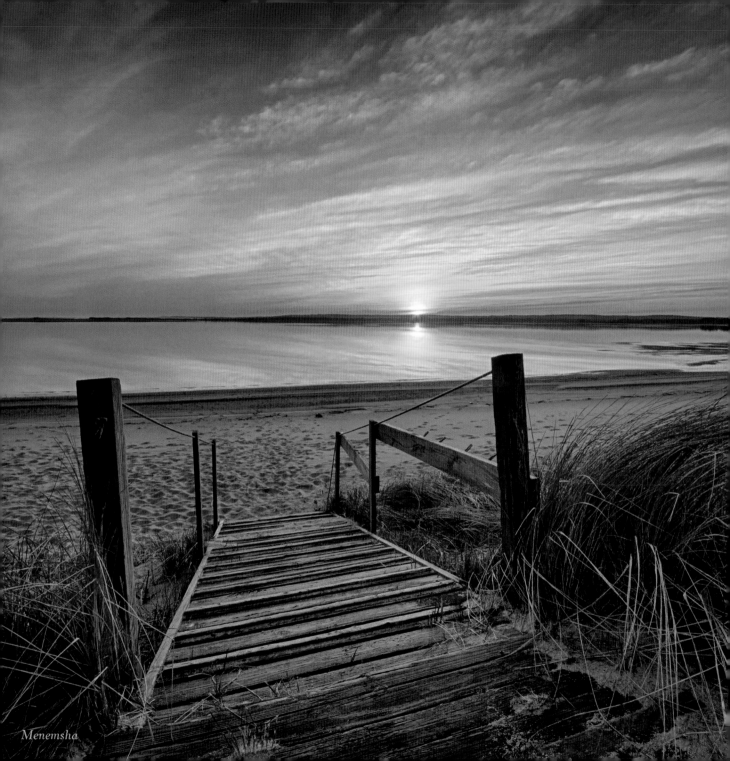

Menemsha

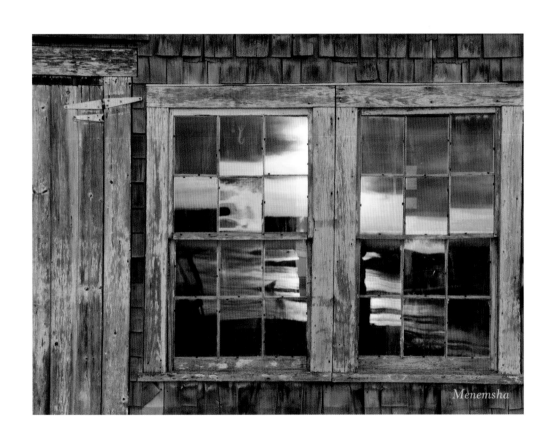

Menemsha

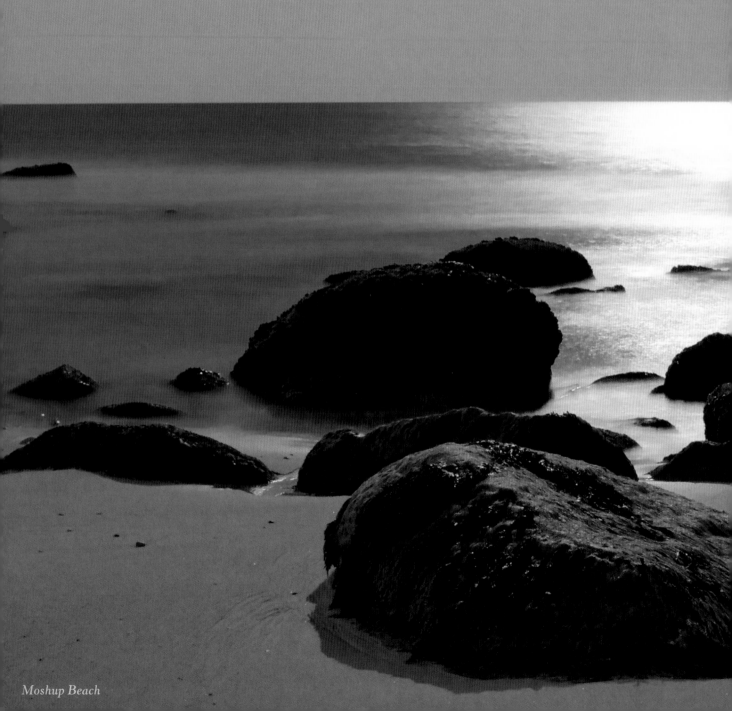
Moshup Beach

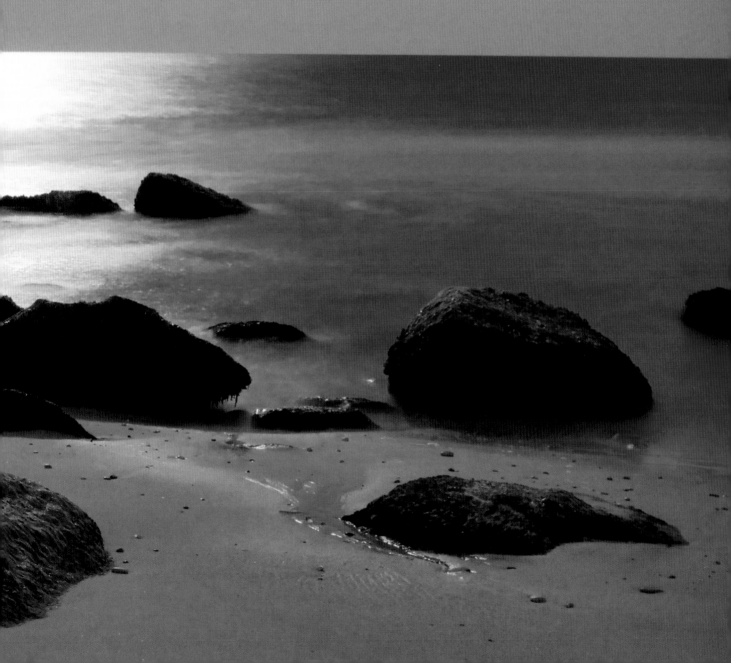

BEING GRATEFUL

Edgartown

LESSON 15

I LISTENED TO A MOTIVATIONAL speaker at a seminar who questioned whether depression could exist in a state of gratefulness. How is it a movie star with infinite wealth can die of a drug overdose where a person with nothing can be at peace and connected to life? No matter what level or station in life, the gap between what you have and what you believe you should have, can take you down. Be grateful.

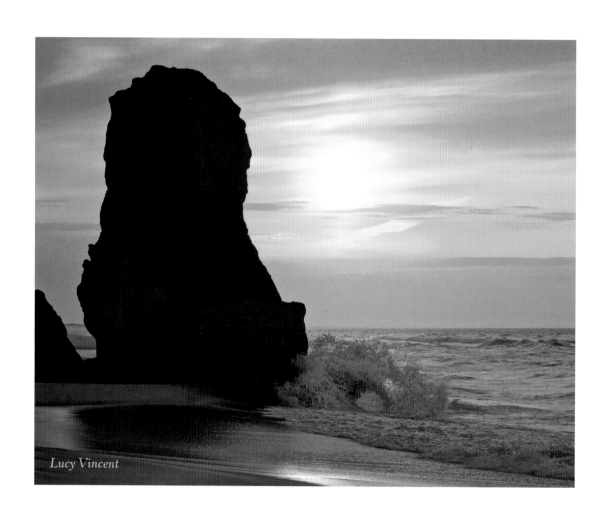

Lucy Vincent

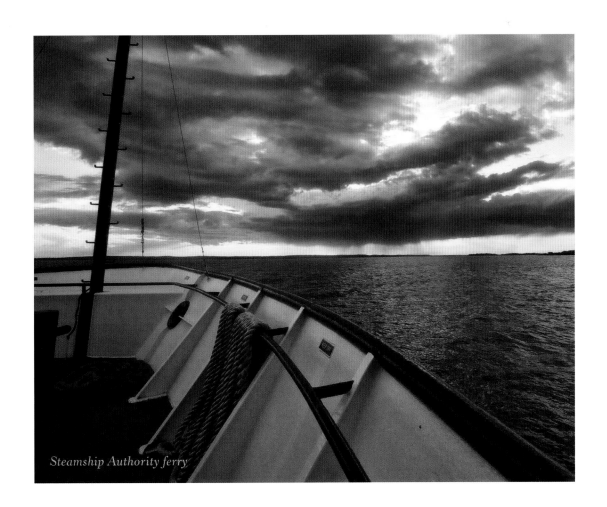

Steamship Authority ferry

FINDING HOPE AND SERENITY ON MARTHA'S VINEYARD

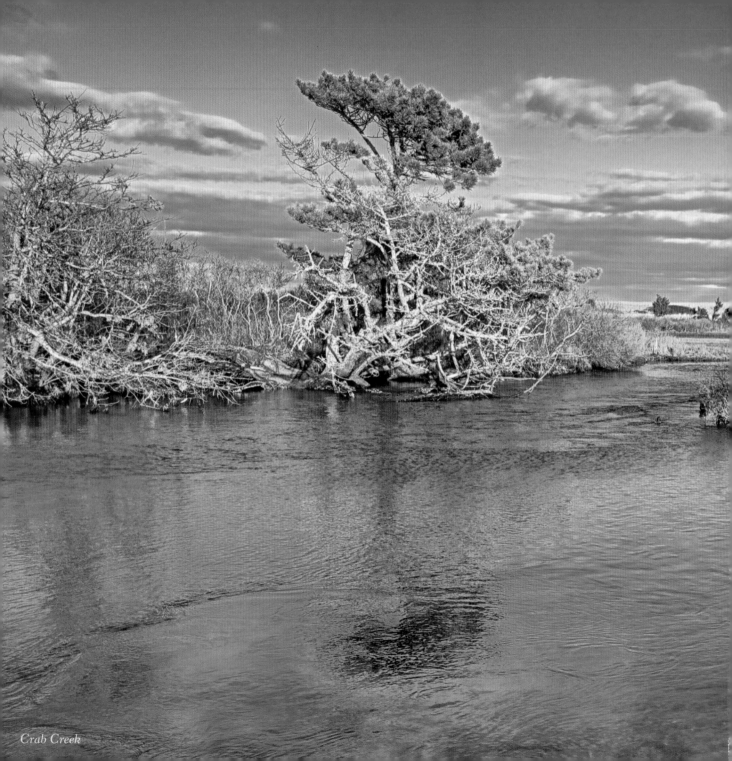
Crab Creek

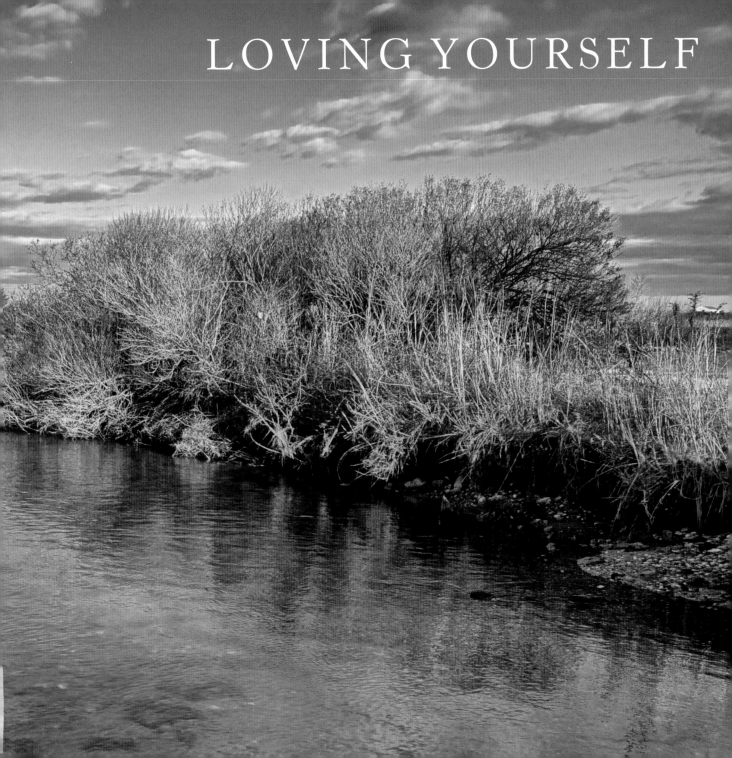
LOVING YOURSELF

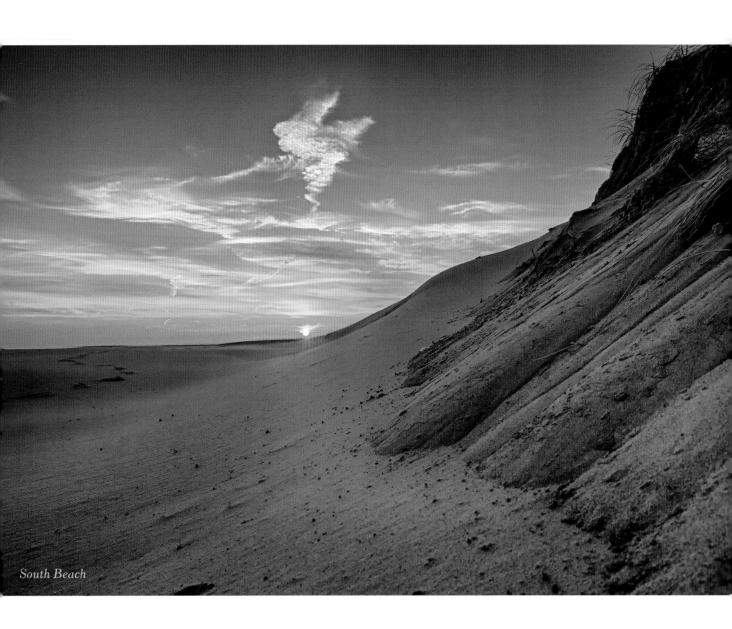

South Beach

I HAVE NO MAGIC ANSWER on steps to take to start to love yourself as unique and beautiful. I am not naive and realize there are many paths to being miserable. But everything in life comes down to personal decisions. If you are unable to decide to be happy, fake it till you make it. Help someone or something and you will feel love for yourself. Rinse, lather, repeat.

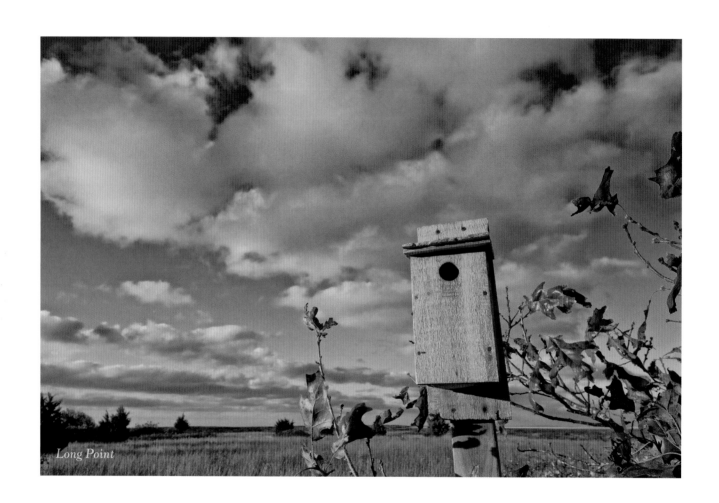

Long Point

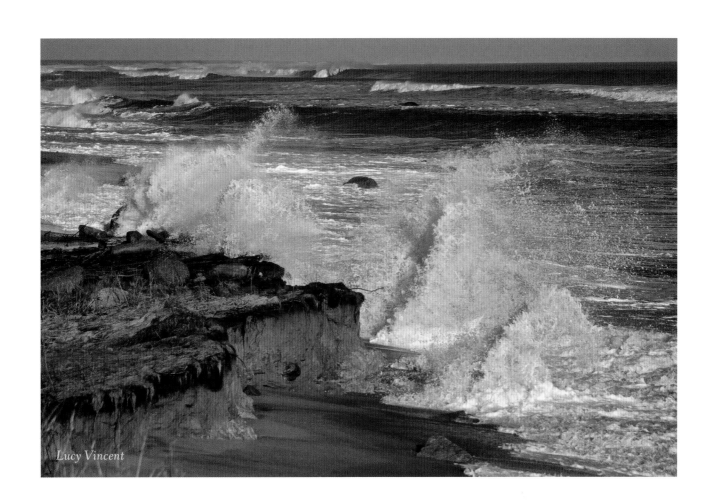

Lucy Vincent

FINDING HOPE AND SERENITY ON MARTHA'S VINEYARD

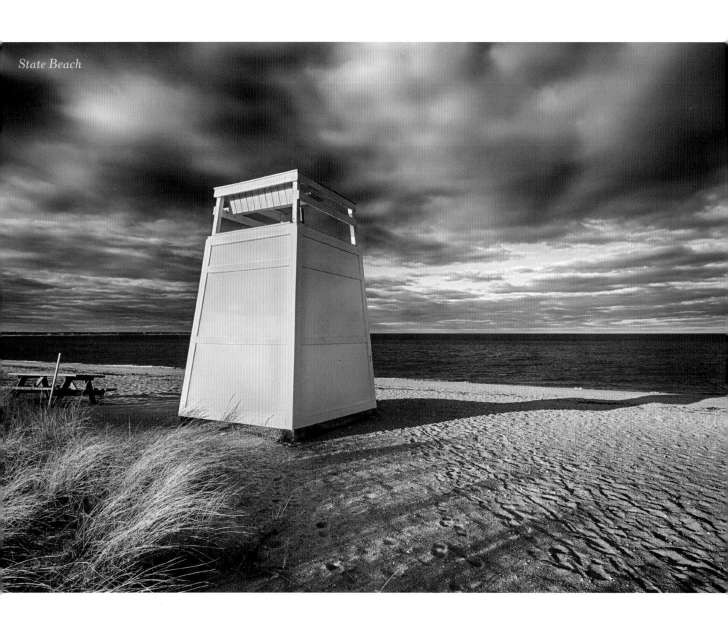

State Beach

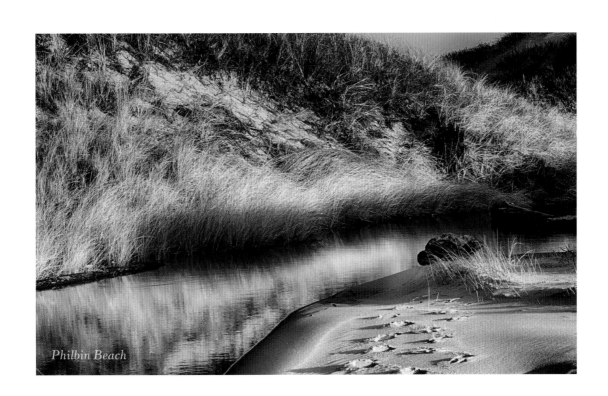

Philbin Beach

FINDING HOPE AND SERENITY ON MARTHA'S VINEYARD

~ 123 ~

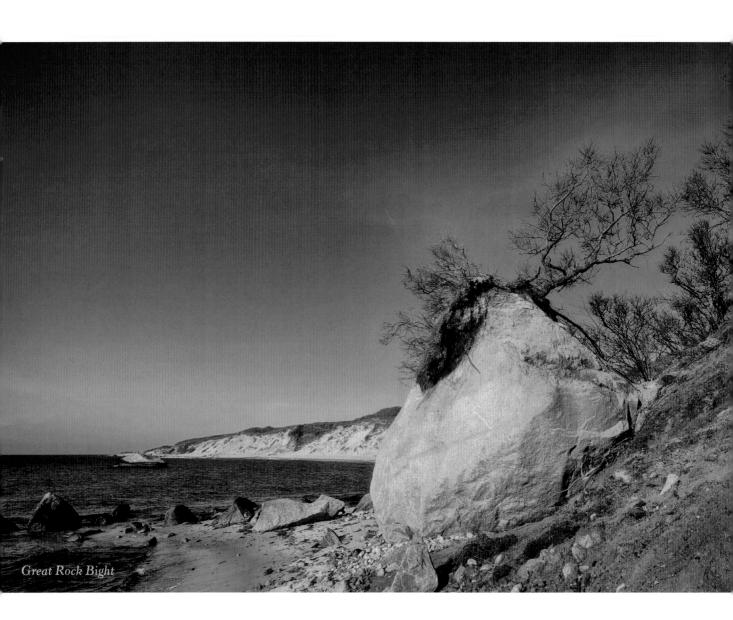

Great Rock Bight

ABOUT THE AUTHOR

The author lives in Maine and Martha's Vineyard with his wife, Linda. He has two children, Mike Jr., who is twenty-seven and living in Cambridge, Massachusetts, and Sarah, seventeen, who is in college. Originally from Connecticut, Mike moved to Boston in 1993 where for over twenty years he worked as a healthcare executive, sales director, and consultant for a variety of companies in the hospital and diagnostic laboratory industry. He is now the chief operating officer of a large laboratory company in Maine while spending weekends on the Vineyard.

He is a licensed Coast Guard captain and lived on his forty-four-foot sailboat next to the USS Constitution in Boston Harbor for five years. A running fanatic, Mike participated in many marathons and road races and continues to hold exercise as a key part to maintaining sobriety. Mike is working on a master's degree in psychology in addition to his masters of science in healthcare administration. He hopes in the future to become an addiction counselor.

ARTIST'S STATEMENT

I have used a series of Canon cameras as my skills have advanced and now use the Canon EOS 5D MKIII. My biggest revelation in the process of addictively acquiring new cameras was the realization the photographer's perspective in taking a photo, and the lenses selected, are more important than the camera itself. The day I acquired a Sigma 10-20 mm extreme wide-angle lens was the day my whole approach to photography changed, and the world opened up to me. When I go back to my computer after a photo shoot, I frequently use High Dynamic Range methods in merging multiple exposures to bring out the detail. I don't alter images by cutting and pasting backgrounds or other techniques that alter the basic construct of the photo. I edit my photos to complete the process of expressing what that moment meant to me.

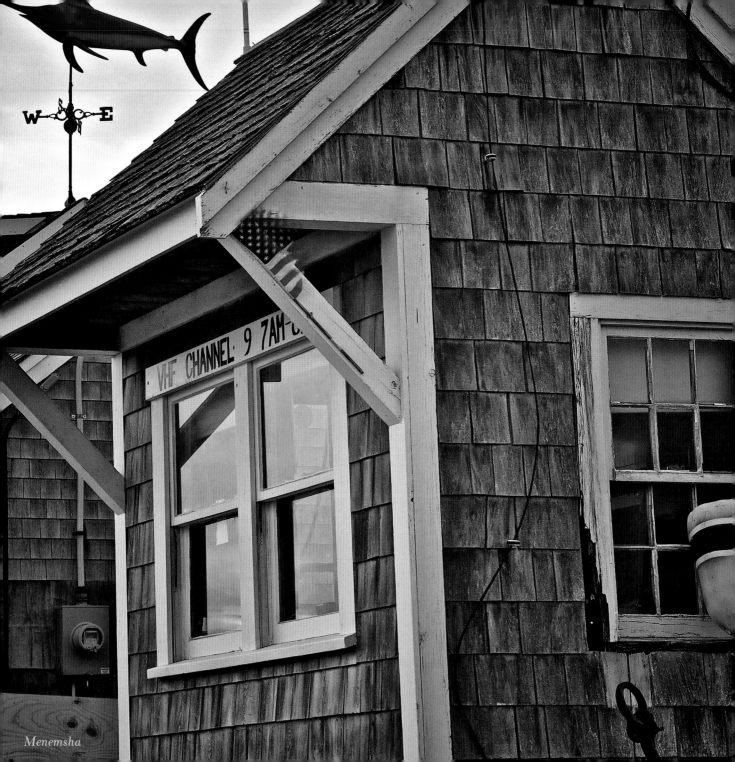

DEDICATED TO MY FATHER

I AM FIFTY-SIX YEARS of age as I complete this book, and my life has not turned out as I had planned. Many regrets and the realization that perfection isn't possible—not even close. But this book is about hope, courage, and a burning desire to do the right thing.

Somewhere in my childhood I had those values placed in my heart. Hope is a recognition circumstances can change for the better despite mistakes made. And it turns out my sense of hope came in the form of my father, Bert Blanchard.

He probably doesn't realize I kept a close eye on him over the years as he changed and grew as a person. He learned to tell his kids he loved them. He honored his commitments and held loyal to friends and family through thick and thin. He suffered losses and the inevitable realization that life is a constant process of letting go. But most of all he taught me that no one person should be judged at any single stop along life's path but rather for the person they become. He instilled in me a belief I couldn't be the person I needed to be without suffering, pain, loss, and the inevitable making of mistakes.

His example gave me the courage to write this book and share my story. He never gave up on me or left my side. For these reasons and more, I take up this mission to help others as they find their path in the absence of drugs and alcohol and become the person they need to become.

I will always be indebted to you, Dad. I love you!

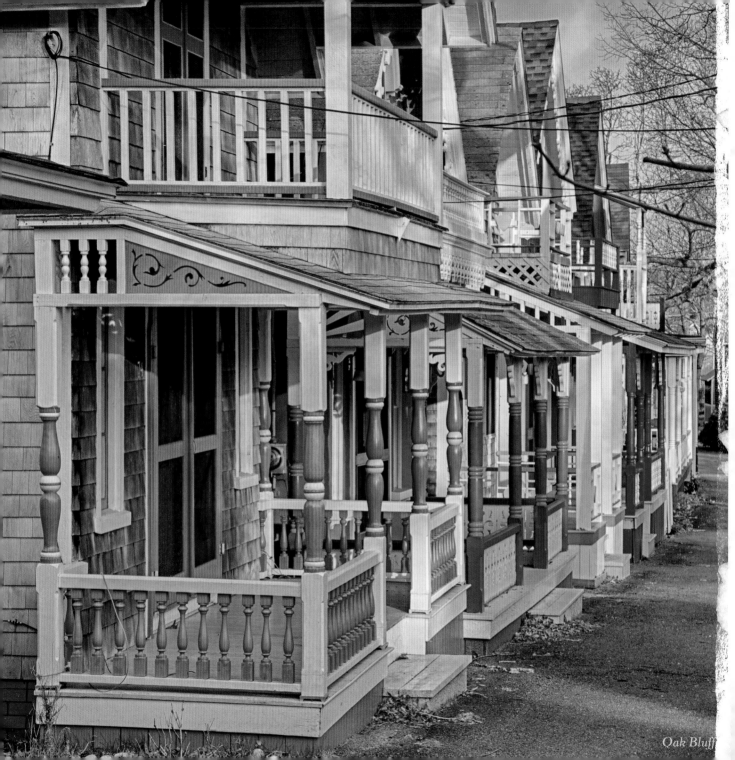

Oak Bluff